Medium Design

Medium Design

*Knowing How to
Work on the World*

Keller Easterling

VERSO
London • New York

First published by Verso 2021
© Keller Easterling 2021

1 3 5 7 9 10 8 6 4 2

Verso
UK: 6 Meard Street, London W1F 0EG
US: 20 Jay Street, Suite 1010, Brooklyn, NY 11201
versobooks.com

Verso is the imprint of New Left Books

ISBN-13: 978-1-78873-932-0
ISBN-13: 978-1-78873-935-1 (UK EBK)
ISBN-13: 978-1-78873-934-4 (US EBK)

British Library Cataloguing in Publication Data
A catalogue record for this book is available from the British Library

Library of Congress Cataloging-in-Publication Data
A catalog record for this book is available from the Library of Congress

Typeset in Sabon by MJ & N Gavan, Truro, Cornwall
Printed and bound by CPI Group (UK) Ltd, Croydon CR0 4YY

Contents

Preface

The objects in a simple room—table, chair, lamp, pen, teapot, teacup, apple, and window—are performing. Although static, they are projecting latent potentials, activities, and relationships. The chair is sized to accommodate a seated human body, and the table is sized to allow the human and the chair to slide underneath it. The teapot and teacup have handles that fingers can wrap around, and the apple is a fruit that a hand can grasp. Some of the interactions are timed. The tea will go cold. The sun will go down, and the lamp will go on. Each of the objects in the assembly offers some properties or capacities that are in interplay.

Culture is very good at pointing to things and calling their name, but not so good at describing the chemistry between things or the repertoires they enact. It is easy to see how a sailor or a meteorologist works within swirling kinetic atmospheres of air or water, but not so easy to see the interactivity between static objects that make up any ordinary surrounding environment. These things with names, shapes, and outlines are usually valued in markets and possessed as property, and they are generally regarded to be inert or inactive rather than dancing with interdependent potentials.

The periodic table charts elements according to their reactivity, volatility, or tendency to generate molecular bonds. But if thousands of years of history are any evidence, culture perceives substances like silver and gold not as entities in an array of potentials, but as objects—lumps of metal to be hoarded and beaten into adornments or currencies in a primitive urge for

power. Maybe when encountering most substances, technologies, and practices, the modern Enlightenment mind prefers to pluck them from their active matrix and fix their name and position rather than indulging an imagination about their interdependence.

And yet, while perhaps not foregrounded in many cultural scripts, it is quite common to get through the day by managing potentials. The most resourceful, practical cooks know how to triangulate between the contents of their refrigerator, their pantry, and the food preferences of those for whom they wish to cook. Rather than cooking from a recipe, the mind clicks through hundreds of possible combinations between a half cup of milk that will only last one more day, two eggs, frozen peas, baking soda, cilantro leaves, hot sauce, a half stick of butter, a cheese rind, tomato paste, a tin of sardines, and two bananas. Quantities, expiration dates, cooking times, the mood and hunger of the intended recipient, and thousands of other factors are thrown into the calculations until the cook arrives at a meal that is often mistakenly treated as a relatively simple outcome.

A parent with squabbling children does not attempt to litigate or parse the content of the argument, but rather manages potentials in the environment. They might lower the temperature of the room, move a chair into the light, increase the blood sugar of one child, or introduce a pet into the arms of another so that the chemistry of the room no longer induces or supports violence.

A dog hears a human speak the words "good girl," but it does not take meaning from the lexical expression alone. The dog also gathers meaning from many other cues and relative positions between things in context: whether the human is holding a leash and their position relative to the door or the dog bowl. Together with the sound of words, the dog assesses all of these potentials.

Similarly, an urbanist, with something like a canine mind, observes the city as a collection of reactive or interdependent

components. It is easy to see the choreography of moving parts like cars and pedestrians as they synchronize and intersect. But urbanists look at urban spaces like streets and assess potentials even in the relationships between their static solids. An ethnographer may interview the inhabitants. An economist may gather data about livelihood. But an urbanist observes an interplay of physical contours that are also expressing limits, capacities, and values.

A street with many small lots, many doors and windows, and a heterogeneous mixture of uses possesses a chemistry different from a street with only a few large lots, one entry, and one function. Urbanists may observe the relationship between a traffic light, a business that offers coffee in the morning, and a set of buildings that have inhabitants who care for the street. And they can see the matrix of exchanges between a subway stop and a giant building with a huge volume of inhabitants. Not morphology alone, but the interaction between components, determines the richness of this loose and changeable assembly of parts. There may be no set structural rules and few determinants—only some dynamic markers of changing relationships.

The chemist, cook, parent, dog, or urbanist is considering the activities and *dispositions* of objects, where "disposition" describes the agency or potential immanent in an arrangement— a property or propensity within a context or relationship. You might assess the disposition of someone's personality over time or the disposition of a house in relation to the weather or landscape, just as you might describe the disposition of an organization. The disposition of any organization makes some things possible and some things impossible. A ball on an inclined plane possesses disposition. Its position and geometry in relation to gravity and the pitch of the plane sets up a potential.[1]

Even though it may seem to be all too obvious, thinking in this way is at once common, often unexpressed, and profoundly

underexploited. It requires an inversion of the dominant cultural constructs that are dependent on declaration—labeling or defining the recipe, style, property, or ideology. Favoring nominative or quantitative expressions over expressions of disposition, culture privileges what philosopher Gilbert Ryle called the difference between "knowing that" and "knowing how"—something like the difference between knowing the right answer and exercising experienced reactions unfolding over time.

This book rehearses the faculties of "knowing how." It asks readers to look with half-closed eyes at the world, focusing not only on objects with names, shapes, and outlines, but also on the matrix or medium of activities and latent potentials that those objects generate. It looks beyond object to matrix. It looks beyond nominative expressions to infinitive expressions of activity and interplay. And it looks beyond declared ideologies to undeclared dispositions—beyond the authority of economic or political labels that often obscure or misrepresent latent potentials in organizations of all kinds.

A focus on medium over object is ever present in many disciplines. The oncologist follows not only the tumor but also the chemical fluctuations in surrounding tissues. The geologist does not merely taxonomize specimens but rather reads them as traces of a process. The physicist sees all of matter as existing only through ongoing entangled relationships.[2] The actor in the theater transmits information not only through words but also through interdependent actions. Even media theorists are returning to elemental understandings of media as surrounding environments of air, water, earth, or fire.

To further jostle the lexical, quantitative, or ideological expressions on which "knowing that" relies, this book models ideas in lumpy, heavy, physical space. By looking at space as a medium, it is in dialogue with all those—media theorists among them—who are returning to the Latin root of the word "medium," *medius*. Not bound by associations with communi-

cation technologies, "medium" in this context means middle, or milieu.

This spatial language is not just for specialists but rather for a broad audience of thinkers. Space is an inclusive mixing chamber—an especially potent carrier of overlapping political, financial, and environmental ecologies that graphically model some of the world's most intractable dilemmas. Culture may give more governing authority to the newest technologies or to legal or economic abstractions, but space possesses information, value, and potential beyond financial or geometric assessments, and it is itself a technology of innovation. Space is also a carrier of polity—dispositions and temperaments that can elude or enhance the declarations of political platforms.

Perhaps most important, this book exercises faculties for not only observing this space but also changing or designing it. Designers are already renovating an approach to form itself to address emergent global urban spaces and organizations. They are using forms for designing not only things but the *interplay* between things—active forms that enact change in urban spaces, larger territories, and even planetary atmospheres.

Speaking to any reader in any discipline as a designer, the discussion treats design in space as a form of activism with special powers. Just as a contemplation of medium inverts the customary focus on object over field or figure over ground, this *medium design* may prompt practical inventions and paradigm shifts that fundamentally alter approaches to all kinds of political and environmental dilemmas.

Introduction

Designing Is Entangling

Against all reason, some of culture's intractable dilemmas seem to create political, social, and environmental impossibilities—from unchecked concentrations of authoritarian power to organizational cross-purposes to extremes of inequality and climate cataclysms. Consider just a few of these as they are inscribed in spaces and territories.

While global warming is increasingly self-evident, it continues to attract naysayers.[1] Typhoons, hurricanes, and wildfires have given the world a dramatic preview of some evitable and lethal effects, as scientists report that greenhouse gas emissions are accelerating like a "speeding freight train."[2] But governments around the world nevertheless defy global compacts attempting to alleviate the situation.

A global pandemic like COVID-19 is an X-ray of racial injustice and economic inequality as well as a rehearsal for climate catastrophe. Viruses, like atmospheric chemicals, float across national boundaries. They easily infect *homo economicus*. They cannot be evaluated without considering a complex of epidemiological, ethnographic, demographic, economic, and cultural evidence. Just as structural racism in the United States disproportionately puts people of color at a higher risk, many factors can exacerbate illness. Only a more robust interplay between sectors of community can deliver health and welfare. But despite repeated failures, regimes like the United States continue to use thin econometrics to address a biological agent and broken policing to protect whiteness and bloated wealth.

Other contagions carry their own forms of violence. Repeatable formulas for space—*spatial products* for skyscrapers, malls, golf courses, airports, logistical landscapes, and everything in between—now populate repeatable formulas for entire cities. And many of these are "free economic zones" that legalize exemptions from law, privileging the freedom of corporations and offshore finance so that they can operate outside the inconveniences of taxes or labor and environmental regulations. Sweetened with incentives and bathed in elaborate promotional fantasies, this massive, global, infrastructural installation of corporate capital is a major engine of inequality, labor abuse, and environmental brinksmanship. And it is rapidly generating a new layer of the earth's crust.

The same global infrastructure space has perfectly streamlined the movements of billions of products and tens of millions of tourists and cheap laborers in free-zone cities.[3] But at a time when more than 70 million people in the world are displaced —more than at any other time in history—somehow, there is no way to move a few million people away from atrocities surrounding political conflict.[4] And there are still so few ways to accommodate economic or environmental migrations. The legal, logistical, or spatial ingenuity applied to commercial movements is suddenly absent in these situations. The nation-state has a dumb on-off button to grant or deny citizenship and asylum. And the NGOcracy offers as its best idea storage in a refugee camp—a form of detention lasting, on average, seventeen years.

Exacerbating inequality and climate change, more and more people live in cities, but in peripheral areas that are increasingly less dense and staggering in size.[5] They house sprawling wealth as well as the precarity associated with disenfranchisement and migration. According to some predictions, by 2050, this mostly unplanned peri-urban development, now de-densifying more rapidly, will cover 3.1 million square kilometers—the size of the entire country of India.[6]

Preceding the financial crisis of 2008, there was ample evidence of increased risk from the repackaging of "subprime loans" that were attached to buildings in this sprawling periphery. But the financial incentives overwhelmed the certain knowledge of risk. In the global economic collapse that ensued, buildings all over the world visibly fell into ruin. The evening news stared anxiously at the individual home—the germ of this mortgage crisis—as it reported about increased foreclosure rates. But even as the market flooded with foreclosures, new housing was treated as a sign of economic confidence. At any one moment, economists and financiers regarded the house as both a positive and a negative economic indicator—an object simultaneously exacerbating and relieving financial crisis. These assessments were regarded not as irrational or addled but as sound economic science.

Driverless vehicles, traveling in platoons, promise to perfect driving, save fuel, and increase productivity. As is the case with the advent of many new technologies, from railroads and radios to cars and digital devices, this latest technology is treated as an ultimate or superior platform that should make all others obsolete. And digital data is treated as the only information of consequence. But, as has now become abundantly clear, even if fleets of driverless cars are used in lieu of transit, they will create unprecedented forms of traffic congestion—a smart vehicle in a dumb traffic jam.

Although very different in content, all of these dilemmas, together with the powers that preside over them, share an underlying political chemistry that reflects dominant cultural habits. The human and nonhuman entities involved—whether elected officials, construction companies, legislative bodies, or financial institutions—prefer to overlook information that disrupts the status quo or the habitual solution. Ideological narratives or other reinforcing group behaviors galvanize adherents even in the face of looming disaster, and the most extreme and impractical situations can survive. From within its

echo chamber, the prevailing power circulates only compatible or convenient evidence in a closed loop.

Then, given the desire for autonomy or supremacy, when the closed loop is confronted with extrinsic or contradictory information, it often retaliates with a binary fight against any challenge to that status quo. In the face of obvious failure, the organization assumes that its solutions and guiding logics were simply not applied with sufficient rigor. The loop was not tight enough. The group was not ideologically pure enough. The organization then circles the wagons and vilifies the nonconforming element.

The loop and the binary reinforce each other. Evidence of global warming, pandemics, structural racism, financial risk, or technological failure are conveniently deleted. Labor abuse and inequality are soft-pedaled so as not to intrude on the short-term financial advantages of wealth and power. And the worker who challenges the "free" trade of corporations, or the migrant who challenges the borders of the nation, is now deemed to be a contradiction that is the enemy of stasis and security.

The loop and the binary are difficult to escape when default cultural habits of mind reinforce its tautologies and false logics. The modern Enlightenment mind is still present and still replacing god with ideological constructs cobbled together into false wholes. Religions, philosophies, and political regimes mirror each other with different forms of ideational monotheism that search for the one and only—the universal, the elementary particle, and the telos. The narrative arcs of cultural stories bend toward utopian or dystopian ultimates.

Modernist scripts also fuel the binary fight, since to reinforce "the one," bombastic arguments must naturally ask for successive rather than coexistent thoughts or practices. They must wipe away the incumbent. The new right answer must kill the old right answer, and the new elementary particle must now parse the world. The new technology—from railroads to

digital communications—must replace the obsolete technology to create the one and only new platform.

And, still in a monistic thrall, each successor is portrayed as redemptive, transcendent, and liberating. The quest for an impossible freedom usually accompanies these heroic trajectories. Manichean struggles between false oppositions progress toward emancipatory perfection. Chains are shed as each new manifesto is unleashed.

Ur-enemies, like capital, must be comprehensively defeated. Political philosophies (e.g., Marxism) inspire what philosopher Vilém Flusser calls "textolatry"—pure adherence to a theory as the only path toward sufficiently sharp critique.[7] And the impossibility of total epic victory often encourages delay and retreat into narrower and narrower cul-de-sacs that can provide the comfort of autonomy.

But besides these obvious political ultimates, the modern world is one in which emergent ideas must be labeled "radical" or "post." It is a world in which developers of digital technologies long for the algorithm or Turing complete code that, readable across many machines, approaches the universal. It is a world that would take seriously Francis Fukuyama's comical claims about the end of history.[8] *Homo economicus* and Westphalian sovereignty are darlings of most histories. And even science fiction stories often assume the shape of a mothballed tragedy with heroes and struggles.

In all these narratives, mimicking religion or war, cultural change can only occur through combat or collapse. And the fight should build to a revolution or an apocalyptic burnout. These are the hackneyed plotlines of the "humanities."

In the most general terms, maybe the modern mind is addicted to a common, stubborn desire to be right or to "know that." In the earliest moments of development, adults hammer into the minds of children the need to provide the right answer, just as they themselves go to bed every night telling themselves that they were right all along.

Being right is structurally self-reinforcing—the loop par excellence. In a recent book about winning arguments, Stanley Fish quotes an exchange from Monty Python's "The Argument Clinic." Michael Palin, who has come to the clinic to pay for an argument, says, "Argument is an intellectual process. Contradiction is just the automatic gainsaying of anything the other person says." John Cleese replies, "It is NOT!" Unwittingly adding to the comedy, Fish uses the exchange to prove that he himself was right all along about the ubiquity of argument.[9] He can perpetually say, "There you are, you see." He will always be right about the fight that is essential to being right and the argument that is essential to ideation. Culture congratulates itself on the reasonable thinking that arrives at proofs of this sort.

And that same culture is susceptible to political bullies or demagogues who set themselves up as another modern replacement for god offering the drug of being right to their following. Some of these entities, whether individuals or organizations, are political superbugs—something like resistant strains of microorganisms. Thriving on the oscillation between loop and binary, they can attract arenas full of supporters chanting in unison—supporters easily galvanized by a face-off against any nonconforming element.

Under the sway of these habits, culture then continues banging away with the same blunt tools that resist innovation. Shorelines flood due to global warming, diseases take hold, a financial crisis makes properties worth less than nothing, or a migration of refugees swells in number. If economic and military templates of causation provide no explanation, if new technologies provide no solution, or if the consensus surrounding laws, standards, or master plans provide no relief, little sense can be made of the problem.

The smartest people in the world can make brilliant observations of these dilemmas and measure all their dimensions with greater and greater precision. They can take comfort in being more and more right about their observations. But they are still

left standing with hand to brow. The violence and destruction that attends inequality and climate change can also become a matter of irrevocable nonhuman planetary or atmospheric conditions. And if you try to counter political superbugs with the pure dissent of enemies and innocents, you only deliver the fight that nourishes their violence.

How do you drop through a trapdoor to exit these dominant cultural habits, and how do you operate on the special powers of the superbug?

This would be the customary moment to announce a new right answer in manifesto form. But against everything culture holds dear, on the other side of that trapdoor, nothing is new, nothing is right, nothing is free, and there are no dramatic manifestos, ur-enemies, or universals. That conforming move, though perhaps labeled "radical," would be sadly conservative.

Instead, maybe it is only a little easier to see the world at a different focal length—to see, as if through half-closed eyes, a matrix or medium of undeclared activities and latent potentials. Through the very ordinary and practical perspective of chemists, cooks, and parents discussed in the preface, it is easier to see that whatever the content of each of the dilemmas described here, prominent above all is the tendency to form loops and binaries that obstruct change. That potential—that disposition—is itself the object of concern.

It is easier to see that ideologies, so firmly held, are often decoupled from what organizations are actually doing. A declared ideology and an undeclared disposition are misaligned. A populist ideology about distributed power and wealth is used to deliver power and privilege wealth. A global network of Dubai-style free-zone cities facilitates not its storied free trade, but manipulated trade. While flying under the flag of economic liberalism, a political platform maximizes the freedom of the wealthiest minority at the expense of everyone else's freedoms.

And both left- and right-wing ideologies can result in concentrations of authoritarian power.

It is even easier to see what the political superbugs are actually doing to survive. They use obfuscations and contagious rumors to create immunities. They appear to be brandishing ideologies when they are really conflating them or flip-flopping between them. Their lies, distractions, and confusions even seem to turn lexical expressions into physical force fields. One lie activates the rational restoration of truth. But the presence of many lies and distractions—too many to reconcile—begins to build up a Teflon coating on which rationality slips and slides.

The superbug's scrappy and inconsistent use of ideology is only the means to manipulate its real target—the undeclared dispositions and temperaments in culture. Whatever they are saying, all they are really *doing* is sowing division or garnering loyalties and keeping everyone locked in the old loops and binaries. The confusion helps them reinforce their following or make everything about a righteous fight between "them and us." And all this erratic activity, decoupled from content or declaration, further insulates the superbug from reasonable declarations or consistent platforms.

While activism may require ideological declaration and confrontation, undeclared activities can facilitate untouchable accumulations of power and environmental forms of violence. For instance, a sharp leftist critique of capital may be essential to understanding its special traps and contradictions, and yet an exclusively ideological view may fail to respond to myriad other deceptions, concentrations of authority, or sources of violence. And political activism may never succeed without operating not only on declared ideology but also on other chemistries of power that often remain mysterious, unexpressed, or underexploited.

But, most important to this discussion, on the other side of the trapdoor, it is also easier to discover opportunities to alter these chemistries or dispositions—to make them objects of

design. Moreover, since space is often the non-lexical carrier of dispositions like loops and binaries, design in a spatial medium can be an especially potent way of operating on or disrupting cultural habits. And, by remaining undeclared, this design can also offer stealthy or environmental forms of activism.

Designers have joined journalists, social scientists, lawyers, economists, artists, and others in exploring the globalizing world with all of its contagious and repeatable formulas for making settlements of all kinds. While it has been important to deliver evidence about violent and explosive forms of global development, reportage is not enough. Bored with another precise measurement or another rhetorical critique to be consumed within the venues of cultural production, this is a discussion about *manipulating* the spatial medium. A language of design in space is as legible and consequential as any other lexical or quantitative language to which culture gives authority. An understanding of spatial variables even expands what culture regards to be innovation, and it is crucial to anyone working on the world.

Luckily, design is something anyone in any discipline already knows how to do. As observed in the preface, to work with these potentials in ordinary space is to work within a cultural blind spot that is right before you and a *terra incognita* where you have already been.

Conventional design, it is assumed, must wait to be engaged by the market to prepare another right answer—a solution in the form of a building or a master plan. Alternatively, the critical design practitioner must work for the absolute defeat of this market. In both cases, the prescriptive, ideological, modern mind creates an all-powerful capitalism that is the chief source of opportunity or danger.

But the same global space that embodies the most toxic loops and binaries—the distended urban peripheries, rising seas, wildfires, and free zones—harbors many varied sources of violence, lethality, domination, and discrimination, and it

has special powers that inspire a very different kind of *medium design*. Direct political and legislative activism is crucial, even though it may advance slowly. But design work in space need not wait for either the revolution or the client commission. It can begin even now to act with what may, at first, seem like unlikely spatial material.

In this wetter, hotter world, a spatial medium presents not one enemy but rather many fronts and not one metric but rather many metrics—many sources of both productivity and danger that dominant markets often even discard or overlook. When ideological impasses obstruct change, medium design can trade in these alternative spatial markets where many forms of value and risk are immanent in the heaviest physical solids. Setting aside exclusive faith in econometric, informatic, or legal expressions, it can work simultaneously on multiple, varied, overlapping experiments parsed by many heterogeneous variables on many different platforms.

Aspiring to find the solution, declare the end of a problem, or establish stability once and for all often results in a denial of information or an attempt to keep circumstance at bay, but medium design treats solutions as weak positions that do not take advantage of all that space can do. They create monocultures, and they are especially weak in the face of stubborn forms of power, duplicitous political actors, and changing circumstances. Urban space is not a steady state, and any intervention can be gamed or corrupted, but medium design—like the superbugs—might find other ways to be resilient.

Rather than prescribing solutions, like buildings, master plans, or algorithms, medium design works with *protocols of interplay*—not things, but parameters for how things interact with each other.[10] For everyone accustomed to looking for solutions, these forms of interplay may be perplexing.

If asked to describe a field of objects placed before you in strong sunlight, you are likely to note the shape or color of the objects rather than the shifting patterns light stretching

between the objects. And you might not ask for more time to observe a cycle of changes before replying.

Transposing from a nominative to an active register, the intent of designing interplay is not to fix positions but to initiate interactivity—to disrupt loops and binaries. There may be no single new technology or magic bullet but rather a shift in the relationships between things. There may be no single event but rather an unfolding gradient of events. The designer is then temporarily manipulating the *chemistries* of assemblages and networks.

Interplay can rewire an organization, set up interdependencies, or initiate chain reactions. It is the design of platforms for inflecting populations of objects or setting up relative potentials within them. It is less like designing objects and more like adjusting the faders and toggles of organization.

These spaces of interplay build another kind of resilience in the face of dilemmas, but, even when they deal with heavy physical components, they also offer a way to react expeditiously and achieve scale in urgent situations. Some of the replicating spatial products that are spreading rampantly around the world contain multipliers that, when reverse-engineered, have the capacity to amplify a change.

Nothing works, and to worry that things might go wrong is to miss the point. Things will always go wrong. There are only organizations with greater or lesser capacity to provide relief or productivity. And a time-released interplay—like a software that is constantly updated—might have both the practical capacity to react to changing conditions and the political capacity to respond to the moment when it is outmaneuvered. An interplay is a form that keeps working when things go wrong. It is even something that should not always work.

Returning to the political stealth of a spatial palette, an interplay is not an object with a name, shape, or outline. It is the shaping of dispositions and activities, and, like the work of the chemist, cook, or parent, it can remain undeclared. It

might wriggle between ideological binaries. It might even work persistently and impurely to confound political superbugs by using their own techniques.

Medium design would then be something like playing pool, where knowing about one fixed sequence of shots is of little use. But being able to see branching networks of possibilities allows you to add more information to the table and make the game more robust. In pool, you don't know the answer, but with great precision, you know something about what to do next. The balls are sometimes attached to known forms or rules of play, but the art of pool involves assessing their collisions. The player "knows how" to respond to a string of changing conditions over time with an explicit organ of interplay. Medium design, like pool, is *indeterminate in order to be practical*.

And because things are very different on the non-modern side of the trapdoor, just as indeterminacy is prized over solutions, entanglement is prized over freedom as a means to achieve more equitable rights and relations. Freedom from oppression—as occupation, discrimination, or slavery—can never be equated with confused notions of economic liberalism or libertarianism. Sidestepping some of these conundrums associated with freedom and emancipatory manifestos, robust organizations can rely on mutual obligation, checks and balances, offsets, and bargains. And interplay might distribute authorship and agency to many players or provide those players with a means to act where there is a will to do so.

This medium design may be a way to "get on with it" or work around the modern mind. And to that end, the first chapter, different from all the others in this book, assembles a relay of medium thinkers—analysts of sociotechnical networks, political theorists, media theorists, designers, artists, and others—to further rehearse those expressions of activity and disposition for which culture has a blind spot.

While managing these activities is an everyday practical matter, rare is the formal recognition of latent properties or potentials as carriers of information and consequence that should have authority in global decision-making. The chapter dwells on disposition in space until it is no longer so easily eclipsed by solutionist thinking. And as it hands off to designers, the relay considers interplay as an innovative form that can expand the design repertoire to serve both spatial and nonspatial innovation. Designing is entangling—the simple act of encouraging interdependence.

The four chapters following this initial set of contemplations each find fresh powers and practicalities in more and more non-modern inversions of default cultural scripts. Moving from the domestic and urban to increasingly environmental scales, each addresses dilemmas introduced above—from land use in urban peripheries to inequality, automation, climate change, and migration. Each also cumulatively draws from the content of previous chapters.

These four chapters are organized in four parts. The first part surveys a situation, while the second part considers shifted perspectives that medium design might offer. The third part models relevant examples of interplay, and it may sometimes read like a playbook tracking the changing sequential moves of an unfolding game. The fourth part considers the cultural narratives and persuasions that must also be designed to propel a change through culture. It may not be enough to mix new chemistries of space in the absence of these narrative catalysts that can also alter the physical contours of power.

To further nourish activist calculations, brief interludes between the chapters consider iconic episodes of political metastasis or remission that remain mysterious in part because of their underlying or unexpressed activities and dispositions.

Culture often longs for comprehensive solutions to perfect or defeat what it believes to be a single financial market of exchange. But in Chapter Two, solutions are mistakes, there are multiple markets of exchange, and the interplays that shape them should not always work.

Repeatable dwellings in the sprawling urban periphery are agents of inequality and climate change. Some are spatial products like McMansions, while others are precarious constructions of poverty.

Economic solutions may promise to solve urban problems by fulfilling the dreams of economic liberalism, but medium design considers multiple experiments and mixtures of spatial and financial variables—a broader portfolio of proximities, densities, morphologies, and situated relationships offering more tangible forms of exchange, risk, and reward.

Both historical and contemporary examples of interplay, rehearsed in projects around the world, begin to animate heavy spatial assets and values derived from arrangement. The examples offer safeguards and forms of resilience as they unfold over time and become more entangled in social, political, and environmental ecologies.

In a culture galvanized by visual evidence and quantifiable solutions, designs that operate on latent unfolding potentials may not initially have sufficient authority in global decision-making, however explicit they may be. But, precisely because they encourage interdependence, forms of interplay may even be behind the success of some economic approaches.

Interrupting the modern quest for the new and the emancipatory, Chapter Three looks for sophistication not in the succession of technologies but in the relationships, even entanglements, between technologies.

The contemporary digital ubiquity that sponsors new dreams of automated transportation often eliminates the information immanent in space in an attempt to be "smarter." When culture replaces incumbent technologies with new technologies, it often reaches for something regarded to be more sophisticated but returns to something more primitive. This habit works against the premise of digital architecture itself—that organizations are more information-rich when they are messy and redundant. Although it may be clear that the exclusive or pure embrace of the new and the modern makes culture dumber, the impure embrace of coexistent technologies is surprisingly less common.

The coexistence and interplay between emergent and incumbent technologies redoubles the material for design ecologies. The approach treats the physical material of space itself as a *heavy information* network. Potent and complex spatial variables do not need the screens and sensors of the internet of things to animate their stiff arrangements. They are already dancing.

The chapter considers switching interplays between low-capacity autonomous vehicles and high-capacity transit as a robust, diverse exchange between digital information and heavy information and perhaps the most plausible approach to the coming transitions in transportation.

Persuasions that accompany these interplays can expand and renovate the ways that culture characterizes innovation while reaching into popular culture to manipulate expectations associated with mobility. Inclusive of more than the digital, physical space may be an underexploited medium of innovation with the capacity to mix different species of information—technical, cultural, political—to be truly information-rich. And while switching between transportation modes is regarded to be an impediment to "freedom of movement," it may really be a release into the richness and speed of entanglement.

While problems are typically treated as something to be hidden, discarded, or redeemed with a solution, Chapter Four considers the productivity of multiplying and combining them.

Climate change exacerbates all the failures discussed in this book, but spatial assets facing environmental or financial failure can often be useful precisely because they have failed.

While the modern mind is deflated by failure, medium design exploits the potency of problems rather than trying to tame or solve them. Problems carry with them the potentials associated with needs and experiences. It is not even the content of problems but rather their interplay that is most important. Interplay can combine problems as raw materials to leaven and catalyze each other.

The interplays discussed in this chapter turn needs into a currency of exchange. They arrange urban castoffs in new ecologies. They even leverage climate risks to gain relief from those very dangers.

The cultural narratives that attend these interplays are about ratcheting changes that can quickly gain scale. And they envision a planetary network of failures and remainders—a terra incognita that is constantly renewed and explored.

While overt displays of violence attract the attention of most familiar histories, Chapter Five considers prevailing latent temperaments in organizations.

In medium design, organizations have an inherent temperament. In the same way that glass does not have to break to have a brittle disposition, they have a capacity to include, exclude, nurture, or harm, even in the absence of event or declaration.

The interplays previously discussed—about inequality, mobility, and climate change—all impact patterns of global migration. Rather than the drawn sword, the gunshot, or the military battle—all mainstays of historical narratives—global

migrations often embody what sociologist and mathematician Johan Galtung calls "structural violence." And humanities scholar Rob Nixon identifies migrations impacted by "slow violence"—the disproportionate damage and attrition inflicted by inequality that is also often accompanied by environmental, atmospheric threats.[11]

The interplays discussed here demonstrate the ways in which latent violence can work very differently from overt violence. Adding more inversions, in the medium design that considers temperament, joining a fight can be capitulation, and submission can be empowering. The final interplay considers climate change and migration together as the prompt for transnational forms of exchange and cooperation that bypass the ideological and diplomatic deadlocks over global warming.

Like the parent mentioned in the preface, design can adjust temperament and reduce violence in organizations, but the modern mind spins most of its cultural narratives around conflict and even sees peace as a corollary of war. Medium design replaces those tedious narratives with stories of migration as an adventure prompted by changes to the planet. This environmental exploration has no frontlines but is instead distributed everywhere—at the scale of both microns and atmospheres.

An afterword looks for special activist tools in superbug tricks and other mysteries featured in the interludes—moments when undeclared dispositions deliver political outcomes that diverge from expectations or declared ideologies.

Consider one such trick. During the 2016 presidential election in the United States, counterfeit social media posts used inflammatory racist rhetoric to incite not only political parties but social undercurrents. If focused on the injustice of a racist post, the ideological activist had no choice but to march in the streets to condemn this hate, and that activism will hopefully, eventually yield systemic change. But considered in terms of

disposition and temperament, in the short term, a binary divide helped to elect Donald Trump. The superbugs can convert dissent associated with an opposing ideology into fuel for their own engine.

Direct activist stances must remain resolute, but supporting and expanding this activist repertoire, design needs to be as good as the superbugs at both manipulating dispositions and telling contagious stories. Design can contribute to what philosopher Jacques Rancière has called "dissensus"—not the ossified consensus that is often the goal of power and the end of politics, but the destabilizing of aesthetic signals as they bounce through culture. Beyond declared intentions, works of art and design can shift political ground through the undeclared or ongoing activity they initiate under the radar.[12]

Interplays, or the narratives that accompany them, can neutralize a binary, take advantage of a multiplier, or find a means to leverage or switch a flow of potentials. The designs may make something contagious or generate a Teflon surface of their own. While not betraying an ideological creed, they may sometimes work on an undeclared disposition threatening that creed. They may offer an emotional message that has a surprising cultural bounce because of its inconsistency, irrationality, outrageousness, cuteness, or violence. And they may require a strong stomach for the impure narratives that nevertheless move toward greater justice.

Medium design is not a thing. It has no content. It is only an ever-present approach to many things—an expanded means to generate change outside of some dominant cultural habits. After taking a hard pass on utopian proclamations and master plans, some of what remains are extra-political and aesthetic capacities in spaces of interplay—the latency, indeterminacy, entanglement, heavy information, failure, temperament, and discrepancy that the modern mind abhors. It is an endeavor that may not be for everyone. Instead of seeking solutions alone, you can address dilemmas with responses that do not

always work. Multiplying problems can be helpful. Messiness is smarter than newness. Obligations are more empowering than freedom. Histories can expand to include latent dispositions as well as discrete events. And discrepancy tutors sly forms of political activism that might more successfully outmaneuver the world's most cunning superbugs.

Interlude One

Among the superbug's many survival techniques, in addition to lies and obfuscations, are mediagenic fantasies of all sorts. But the mysterious political instrumentality of these messages may rely less on their content and more on their persistent deployment.

During a 2018 summit, Donald Trump offered Kim Jong-un a movie trailer–style video projection of North Korea after the floodgates had been opened to the global marketplace. While the global press found its Hollywood stylings inexplicable, Trump was only offering the common currency of contemporary global real estate and trade. The video was just another of hundreds of similar examples produced in the render farms at the direction of real estate and infrastructure kingdoms all over the world. They usually advertise the contagious urban formula for free-zone world cities—a seemingly bulletproof spatial superbug of global urbanism.

With all the repetition and monotony of pornography, these three-minute clichés of global urbanism usually begin in outer space as a new era is dawning. Typically, in a city below, a Star Wars–style fly-through threads through a field of digital skyscrapers sprouting from the ground before swinging over industrial areas, container ports, and resorts. The voice-over announces all the neoliberal mantras of free trade: no taxes, cheap labor, streamlined customs, and deregulation of labor and environmental law. "What a Feeling," the theme song from *Flashdance*, plays as one video advertises its city's logistical apparatus.[1] Or a Yanni-like soundtrack accompanies

magnificent claims of world-city urbanity enjoyed by doughy cartoon humans rhythmically waddling along boulevards or plowing forward, stone-faced, in speedboats. A population of villas flips into place as more animated figures weightlessly pad through the lush gardens instantly appearing around them. A flyover surveys golf fairways shaped like pandas and fields of identical candy-colored villas. In the dramatic finale, to the swelling music from *Titanic*, confetti, glowing sunsets, and bursting hearts precede a pan back into the stratosphere, past fireworks and orbiting satellites.

Even before the summit, the Democratic People's Republic of Korea (DPRK) had created its own ecstatic videos that mapped existing or projected economic zones for industry or tourism on the eastern coast or on the borders with Russia and China. Subtitled in English by the Voice of Korea, one of these videos deploys the usual apparatus, including stratospheric views and a finale of fireworks. Throughout, it shifts frantically through a number of up-tempo musical themes—synthesized harps, organ polkas, patriotic marches, high-pitched accordion jigs, bongo interludes, or emotional lullabies and waltzes.[2]

The White House trailer followed the prevailing template to the letter. It only diverged from the norm with an extra celebrity conceit—a pause to announce that the feature was "starring" Kim Jong-un and Donald J. Trump.

In all of these videos, the rhetoric is decoupled from the disposition of the organization. The free zone is both a closed loop and a multiplier. It only circulates compatible circumstances, while also expanding into more and more territory and serving as an incubator for more and more replicating spatial products. It deploys all the scripts about the "smart" city, but it grows dumber as it grows bigger. In the name of freedom, emerging nativist arguments want to bring jobs back to the home shores of nations. But also in the name of freedom, corporations have been working for decades to build this vast international physical plant of free zones that allows them to take advantage of

the cheapest labor in the world. And this "free trade" is actually manipulated trade that primarily privileges the freedom of corporations and offshore finance.

But all of this is obvious, and none of it bothers Trump, Kim, or the zone. All three superbugs are way ahead of everyone. They know that contemporary urbanism seems to be largely driven by revenue streams laced with fiction. Spatial accoutrements within which there is an evacuation of law perfectly suit the dreams of real estate, totalitarian regimes, and political bullies.

Characters like Trump and Kim provide strong evidence of many markets of persuasion and many sources of violence beyond the ur-enemies identified in left-right ideological fights. Their totemic fairy tales are not pre-capitalist anomalies, but rather cultural constants that are only occasionally and inconsistently accessorized by capital.

Superbugs would never rely solely on solutions, reasonable declarations, or consistent ideological platforms. In their own crude terms, that would be like bringing a knife to a gunfight. Solutions are too weak. None of the sentiments related to the free market, capitalism, economic liberalism, or communism mean anything apart from the populations they can mobilize through residual loyalty. The two leaders only have a sense of whether or not attention and power are consolidating around them. These are the dispositions, potentials, and temperaments that superbugs read so well.

Unburdened by mounting evidence and running rings around earnest declarations, the superbug knows how to create chaotic atmospheres in the absence of meaning and information. The rough and bumpy surface of a shark's skin creates just enough microturbulence to aerodynamically streamline the animal's movements through the water. Similarly, the superbug's changing stories and contagious rumors insulate and lubricate its passage through a political landscape. The uninformed and unreasonable stupidity that others are futilely trying to reconcile is its white-sugar fuel.

In a 2020 press briefing for the Coronavirus Task Force, Trump referred to the virus as "genius," a term he usually reserves for himself. Speaking about the 1917 pandemic and the ability of viruses to resurface, Trump said: "You read about 1917 and you read about certain things, but you think in a modern age, a thing like that could never happen. Well, it comes back. It is genius."[3] It was as if Trump, who tirelessly refreshes his own story, recognized something of himself in a virus that constantly mutates to survive.

While the turbulence and mutation that attends ideological flip-flops may be ephemeral, political superbugs can enable real biological superbugs and sponsor durable physical, territorial, and atmospheric changes. But the same potentials, present in unlikely territory and activated by interplay, may be effective antidotes.

Chapter One

You Know More Than You Can Tell

To better detect the ways that organizations are often saying something different from what they are doing, return to that blind spot that is right in front of you or the terra incognita where you have already been. Beyond labels, lexical expressions, or other declarations, the cook, parent, dog, urbanist, or pool player mentioned in the preface and introduction assess their environment by managing activities and relative potentials between things that unfold over time—chemical reactions, recipes, or temperaments.

Culture may treat these latent activities as fleeting, elusive, or far away from an actual recordable world, but a reliance on discrete events and declarative statements as a reflection of the world is as dangerous as an ignorance of the incendiary potentials of explosives. As a chemist, cook, parent, or urbanist might attest, the most practical responses take activities and potentials into account. And these dispositions—like the tendency of some chemicals to explode or the tendency of culture to form loops and binaries—are often among the most impactful.

That deadlocked oscillation between closed loops and binary oppositions can even create its own weather to obscure evidence of the real weather—accelerating climate change, sprawling urban peripheries, inequitable free-zone markets, dumb approaches to smart technologies, or contradictory immigration laws described in the introduction. Whatever the content of these problems, culture's persistent and reliable tendency to search for self-reinforcing wholes or square off in a

fight is the perfect opening for political superbugs with a talent for manipulating those loops and binaries as a means to reinforce their own power.

Even though many consequential activities may be undeclared, they can be deliberately designed or inflected. The forms for designing activities and potential may be less familiar than the forms for designing objects. They may be less about determining shape and more about orchestrating interplay. But, for reasons that will become increasingly clear, they might have the capacity to work on the runaway spaces of global development that confound designers, thinkers, and practitioners in any discipline.

The constellation of medium thinkers assembled here—including urbanists, philosophers, scientists, political theorists, media theorists, psychologists, physicists, artists, designers, and others—generates a relay of thought. Their different expressions for activity in organization—performance, agency, disposition, propensity, affordance, property, and tendency—are words that appear in common parlance and will continue to appear throughout the book. Hopefully, they communicate broadly and avoid the unnecessary authority of terminology. The assembled thinkers continually pry attention away from the nominative or declarative and *push the modern mind out of the way* to return focus to commonsense practicalities that may go unacknowledged.

While the relay provides a road map for deeper dives into each individual perspective, the aim here is to make latent activity or disposition more palpable and garner intelligence for the practice of designing interplay in space. The roughly chronological order in which each thinker is introduced may not be relevant since the tradition, if there is a tradition, is often discontinuous. Thinkers are not rejected because they do not belong to a consistent school of thought or political camp. Some posit similar positions without attribution to previous thinkers while others work to more robustly synthesize this

approach precisely because it is at once common and elusive. The reader is invited to triangulate between these and other thinkers who appear in subsequent chapters as the relay goes on and becomes more and more enmeshed.

Knowing How/Disposition

Ordinary language philosopher Gilbert Ryle has already offered to this discussion a contemplation of the difference between "knowing that" and "knowing how"; the difference between knowing the right answer and knowing how to do something.[1] "Knowing how," like playing pool, requires the ability to react to a changing sequence of cues with practical skills that unfold over time. It would be impractical to say that you know everything about the shifting banks and shoals of a river, but you might "know how" to navigate this changing fluvial landscape. You can only "know how" to kiss, tell a joke, or land a plane in high wind. Again, practicality relies on indeterminacy.

Ryle's *The Concept of Mind* (1949) provides an animated discussion of disposition as part of an argument against the Cartesian mind-body split. Disposition is a latent agency or immanent potential—a property or propensity within a context that unfolds over time and in the absence of a reifying event or an executive mental order.[2] A tendency or potential is latent because it may or may not be on display at any moment. Glass is brittle. Rubber is elastic. A dog is aggressive. But the glass does not have to break, the rubber does not have to stretch, and the dog does not have to bite for the potential to remain in play.

This latency can be tricky in a world that favors lexical declarations and observable events. Ryle's deceptively simple discussion of a clown describes the way a clown "knows how" to be funny, but his unfolding response to his audience is not a single "witnessable act."

[T]he reason why the skill exercised in a performance cannot be separately recorded by a camera is not that it is an occult or ghostly happening, but that it is not a happening at all. It is a disposition, or complex of dispositions, and a disposition is a factor of the wrong logical type to be seen or unseen, recorded or unrecorded.[3]

Far from being hazy and unknowable, the knowledge associated with "knowing how" may constitute *most* of what you know. You know that a street with fifty doors has a different potential from a street with two doors. You know that transportation networks that are segregated have a different potential from those that are combined. You know that a building in a floodplain facing sea-level rise now bears a potential risk. This know-how is not predictive, but it does nourish an imagination that manipulates potentials as well as events. And to consider these latent potentials in space is to begin to work around the modern mind and access some additional powers for design.

Tacit Knowledge

Chemist, economist, and philosopher Michael Polanyi refers to Ryle's distinction between "knowing that" and "knowing how" in *The Tacit Dimension* (1966). Inspired by Ryle and Gestalt psychology, among other things, Polanyi constructs a theory for enriching scientific inquiry. Exploring the ways that "we can know more than we can tell," he warns against formalizing all knowledge to the exclusion of tacit knowledge.[4]

Too much formal clarity, Polanyi argues, gets in the way of intelligence. Repeat a word over and over, and its meaning evaporates. A pianist over-concentrating on proper fingerings is paralyzed and unable to play. Polanyi suggests that there are other relational patterns around which the mind is puzzling and building connective networks that may remain

unexpressed. This kind of thinking contributes to "hunches" that are essential to scientific discovery.[5]

Tacit knowledge, considered in many disciplines, has often been used to describe the know-how that informs design decisions.[6] You have a hunch that buildings served by streets and infrastructure gain value through their spatial arrangement. You have a hunch that combining the two transportation networks mentioned above is more robust than keeping them segregated. But in a world that values quantification, even if it leads to false logics, how do you demonstrate the reliability of a hunch?

Polanyi's personal story also demonstrates the complicated relationship between disposition and ideology. Both Austro-Hungarian exiles, Polanyi and his brother, the economic historian and anthropologist Karl Polanyi, in their respective fields, searched for regimes with dispositions that distributed power and countered the tendency toward totalitarian regimes like those from which they had fled.

But, however briefly, the brothers strayed into different ideological camps to theorize that same antidote to totalitarianism. In *The Great Transformation: The Political and Economic Origins of Our Time*, Karl Polanyi demonstrated the fallacies of a liberal, laissez-faire utopia that speaks of freedom while concentrating power. Although only initially intrigued, Michael was, with Austrian émigrés Ludwig von Mises and Friedrich Hayek, a member of the Mont Pelerin Society—an inaugural moment for theorizing neoliberal free markets as the means to counter totalitarianism.[7]

Michael and Karl Polanyi were searching for similar dispositions of power, but political labels—like "liberalism"—were insufficient markers of intent. The same label energizes polarized political strategies, like social welfare or laissez-faire, while raising the question about whose freedom is being protected. Political ideologies can be decoupled from the dispositions they foster, and polarized ideologies can construct similar dispositions of power.

Dispositif / Disposition / Oikonomia

Philosopher Michel Foucault's used the term "apparatus" or "*dispositif*" to refer to cultural evidence that is not necessary manifest in declarations and overt events. When asked about his use of the term in a 1977 roundtable, he replied:

> What I'm trying to pick out with this term is, firstly, a thoroughly heterogeneous ensemble consisting of discourses, institutions, architectural forms, regulatory decisions, laws, administrative measure, scientific statements, philosophical, moral and philanthropic propositions—in short, the said as much as the unsaid.[8]

In an indirect echo of Polanyi's statement that "we know more than we can tell," Foucault went on to make a distinction between the *dispositif* and the episteme, saying "the *episteme* is a specifically *discursive* apparatus, whereas the apparatus in its general form is both discursive and non-discursive, its elements being much more heterogeneous." Again, it is about "the said as much as the unsaid."[9]

Foucault seems to be looking for ways to expose the mysterious or duplicitous ways that cultural powers and potentials might be embodied, not only in lexical expressions of law and governance, but also in spaces and arrangements of institutions and cities. *Dispositif* is a means to analyze the ways in which "a particular discourse can figure at one time as the programme of an institution, and at another it can function as a means of justifying or masking a practice which itself remains silent."[10]

Foucault's use of "*dispositif*" or "apparatus" prompted two other notable inquiries—one by philosopher Gilles Deleuze titled "What Is Dispositif?" and another by philosopher Giorgio Agamben titled "What Is an Apparatus?"

For Deleuze, Foucault's *dispositif* models a world that does not adhere to the dreams of the modern Enlightenment mind. The *dispositif* is a tangle of "lines of visibility and enunciation,

lines of force, lines of subjectification, lines of splitting, break-age, fracture, all of which criss-cross and mingle together." The *dispositif* contributes to the "repudiation of universals." The apparatus yields no elementary particle. Instead, "each apparatus is a multiplicity," each tracking distinct processes. Deleuze writes, "It is in this sense that Foucault's philosophy can be referred to as pragmatism, functionalism, positivism, pluralism."[11]

Agamben also associates Foucault's *dispositif* with a prac-tical world. He considers *dispositif* within a set of related expressions or a "family of terms" that share the same roots. The French word *dispositif* derives from the Latin word *dis-position,* and *dispositio* is the Latin translation linked to the Greek word *oikonomia*—the economy or management of the household.[12] Foucault's own writings about the art of gov-ernment liken it to a household economy with a parent who knows how to organize relations between people and things—like the parent mentioned in the preface who does more than parse declarations.[13]

Agamben's contemplation of *dispositif* also includes an invitation to expand what might be considered to be appa-ratuses or networks beyond those that fascinated Foucault to include "literally anything that has in some way the capac-ity to capture, orient, determine, intercept, model, control, or secure the gestures, behaviors, opinions, or discourses of living beings."[14]

New York City's Commissioners' Plan of 1811 rolled out a grid over the whole of the island of Manhattan with the rigidity and bombast of a master plan. And for those from whom the Manhattan developers seized land, the grid surely possessed that violence. The geometry could be named, and the city could organize navigation with numbered streets. The grid could even serve as an iconic image of the city.

And yet the matrix of the activities contained within the city grid often generated a very complex social and morphological

fabric at odds with a master plan or the apparent neutrality of the grid. Parts of the matrix could be observed and formalized, but others were fleeting and undeclared. Some blocks sponsored enormous diversity due to countless social, technical, and morphological reasons.

All of these factors and more, separately and in complex mixtures, constitute a *dispositif*. They contribute to situated, latent urban potentials or dispositions. And in the most ordinary ways, and without declaration, many people *know how* to contribute to this housekeeping in an urban matrix like the Manhattan grid.

Affordance

Observations of the simple room mentioned in the preface—in which static objects like a table, chair, or teacup are seen to be actively performing—learn from the formulations of psychologist J. J. Gibson. For Gibson, each object is offering an affordance or accommodation that interacts with another. A flat floor accommodates the walking body, or the height of a chair corresponds to a bend in the knee. Like disposition, affordance can describe a latent or potential activity. You design the teacup to have a handle and the street to have a sidewalk, and you describe what it "does" in active terms.

Gibson introduced the word *affordance* and developed it in his writing about perception over a period of years, but the most often referenced explanation appears in the 1979 book *The Ecological Approach to Visual Perception.*[15] Like others in this relay, Gibson, within his own discipline, is trying to get to the other side of a declarative register. Occasionally referencing systems theory, the environmental movement, phenomenology, or, like many here, Gestalt psychology, Gibson argues that while psychologists focus on the quality of objects, it is the affordances of objects—what you can do with them—that is first perceived.

And while you might make declarations about objects and assign names and meaning to them, you can also observe affordances within an "ecology" of perceptions. Gibson writes, "You do not have to classify and label things in order to perceive what they afford." Affordances are both "physical and psychical" or "a fact of environment and a fact of behavior."[16] While the object has durable potentials or capacities, it can be used in different ways. Before knowing the word "rock," a baby picks up a rock because it fits into its hand. A rock that is four inches in circumference offers an affordance because it fits into an adult human hand. But that adult can use the rock as the building block of a wall or as a weapon to throw through a window.

Designers join many disciplines that use the word *affordance*.[17] They are constantly working with or generating affordances like the teacup handle that allows interaction with a hand. In the Manhattan example, the short span of wooden timbers was an affordance corresponding to small lots, many lots in a block, and many doors on a street. A street that serves buildings affords utilities and the space for interaction between the buildings. A transportation network like rail affords capacities, speeds, and experiences different from those of a highway network. The risk of flooding due to rising tides is a negative affordance for a building in a floodplain. Nothing is causal or classifiable in these complex *dispositifs*, but there are capacities to recognize when designing an interplay or ecology of spatial components.

Actant

Broadly referenced in contemporary culture, philosopher, sociologist, and anthropologist Bruno Latour indirectly echoes many of the thinkers assembled here with a theory about the agency of things. His actor-network theory (ANT) models the matrix of activities that attends social and

technical networks—in everything from the smallest scientific observations to the complex of planetary scale infrastructures and environments.

Offering critique and expansion to yet another discipline, Latour notes that the social sciences often privilege human agency in these networks when they are really the result of interactions between human and nonhuman actors. Things are *actants* that induce action from humans. Both reciprocally format each other. Rather than making declarations about objects that reinforce existing assumptions, Latour calls attention to an unfolding trajectory of activities between humans and nonhumans that is harder to determine.[18]

Nothing then can be merely an object. Latour argues that you often observe active phenomena until you think you can declare "what it is"—its stable, essential "competence." But "what it is" can never be separated from "what it does."[19]

All the components in all the examples above—buildings, streets, timbers, trains, highways, teacups, and rising tides—are actants offering an affordance.

Latour distinguishes himself from some social scientists who precede him. For instance, he draws from a sociologist and anthropologist like Pierre Bourdieu, but attempts to escape Bourdieu's structuralist position. Similarly, Bourdieu's very particular use of *disposition* and *tacit* (without direct reference to either Ryle or Polanyi), while sometimes sympathetic to this discussion, would nevertheless constrain it. Disposition for Bourdieu, often refers to an ingrained habit or a *predisposition* in a social structure, but in this discussion, disposition is a potential existing in sociotechnical or human/non-human arrangements. Moreover that potential is often unfolding in relationships that are indeterminate and impossible to predict.[20]

Also important to this discussion, Latour theorizes "non-modern" thinking. To simply recognize the uncertainties and potentials of entangled activities that defy modern declaration, hierarchies, and ultimates is to step into another realm of

possibility—the other side of the trapdoor. He writes, "Another field—much broader and less polemical—has opened up before us: the field of nonmodern worlds."[21]

Assemblage

The relay becomes more reverberant in the work of political theorist Jane Bennett. In *Vibrant Matter: A Political Ecology of Things*, she draws on the work of many of the thinkers collected here—Latour, Foucault, Deleuze and Félix Guattari, Rancière, philosopher François Jullien, and feminist philosophers Donna Haraway and Karen Barad, among many others. Referencing Deleuze and Guattari, Bennett contemplates the agency of "assemblages" of things, from ordinary household objects to giant utility networks to hurricanes or wars on terror. Quoting Jullien, she likens this agency to the Chinese tradition of *shi* or "...the kind of potential that originates not in human initiative but instead results from the very disposition of things." [22]

For Bennett, the 2003 electrical blackout on the eastern coast of the United States modeled just such an assemblage or "political ecology." The electrical grid, Bennett writes, was a "volatile mix of coal, sweat, electromagnetic fields, computer programs, electron streams, profit motives, heat, lifestyles, nuclear fuel, plastic, fantasies of mastery, static, legislation, water, economic theory, wire, and wood—to name just some of the actants."[23]

Her observations align with those of Rosalind Williams, who, within the context of science and technology studies, stretches Foucault's notions of *dispositif*, arguing that gigantic infrastructure organizations challenge customary approaches to "place-based resistance" because they are too large to be in any one place.[24]

Bennett approaches agency and responsibility in environmental assemblages with no easy sense of moral liabilities or points of political leverage. Within the "billiard ball causality"

of these large organizations, it is not especially effective to simply declare an ideological position against a single force. "Outrage," she writes, "will not and should not disappear, but a politics devoted too exclusively to moral condemnation and not enough to a cultivated discernment of the web of agentic capacities can do little good."[25]

For Bennett, the blackout itself is a political act with "the power to startle and provoke a gestalt shift in perception." New relations and public spaces emerged in its wake. She references Rancière's explorations of the unexpected bounce of aesthetic signals in culture. It is often not the content of the work but the ricochet itself—the action rather declaration—that carries the most important information.[26]

When contemplating how to act on or within an assemblage, Bennett likens it to riding a bicycle—a skill that coincidentally is often associated with the tacit knowledge about which Michael Polanyi theorizes. It is something you "know how" to do. Bennett writes:

> Agency is, I believe, distributed across a mosaic, but it is also possible to say something about the kind of striving that may be exercised by a human within the assemblage. This exertion is perhaps best understood on the model of riding a bicycle on a gravel road. One can throw one's weight this way or that, inflect the bike in one direction or toward one trajectory of motion. But the rider is but one actant operative in the moving whole.[27]

The bicycle rider, like the pool player, may be something like a designer, who makes no single prescription but rather makes many deliberate, even extremely precise and consequential, choices in an unfolding interplay.

Media

In yet another recent synthesis from media theory, John Durham Peters is among those media theorists who look

beyond associations with communication technologies to consider earlier uses of the word *media*. He joins those returning to the Latin root of *media, medius,* as it has come to mean *middle* or *milieu* or as it is used to describe elemental atmospheres like water, air, earth, or fire. In *The Marvelous Clouds: Toward a Philosophy of Elemental Media*, Peters contemplates this expansive return by referencing an array of thinkers in the arts and sciences including Agamben, Gregory Bateson, Foucault, Deleuze, Latour, Flusser, and Gibson among many others.[28]

"Media," Peters argues, "are vessels and environments, containers of possibility that anchor our existence and make what we are doing possible."[29] His thinking aligns with that of philosopher Joseph Vogl, who considers media as "an assemblage, a 'dispositive' (in Foucault's sense) of heterogeneous conditions and elements" that cannot be "predetermined."[30]

In Peters's inclusive contemplation, "Every medium, whether our bodies or our computer, is an ensemble of the natural and the artificial, and WikiLeaks, corn syrup, whale oil, squids, Facebook, jet lag, weather forecasts, and bipedal posture are some of the topics that belong to media theory." Peters writes, "Infrastructuralism shares a classic concern of media theory: the call to make environments visible."[31]

Peters and other media theorists express concern about the "uncontainable relevance" of media theory as the "honey of the media concept is being smeared all over the place." At the same time, Peters speculates about media as an apparatus that has "won just as much of a planet-steering role as have more basic nature-engineering media such as burning, farming, herding, or building."[32]

To counter these fears of diluting the term *media,* and to address concerns about the vast territory that media as *medius* or middle may encompass, design might pick up the other end of this work by modeling a means to "steer" or navigate within a spatial medium. Beyond observations of spatial and

infrastructural networks, media theorists and designers can join forces in experimenting with forms of interplay that actually inflect them.

The Interplay of Active Forms

Having gotten the modern mind out of the way, the thinkers and designers assembled here help to make latent activity or disposition self-evident, and most portray it in the most practical and commonsense terms, as a confrontation with what is real and impactful. A number of them refer to gestalt perspectives that bring a background matrix into focus. Many also share a tendency to describe that matrix as lumpy, heterogeneous assemblages of potential in solids and atmospheres. They are suspicious of those cultural forms in any discipline that claim to be in a steady state or that claim to have found the elementary particle of the matrix.

Looking beyond the names of the elements in the periodic table, the chemist is most concerned with their interplay or how they form molecules. Elements are what they are because of what they do. Similarly, beyond the names of objects, the political labels or overt claims of organizations, these thinkers shift from nominative to active registers, suggesting that interplay or bounce within the matrix is a crucial carrier of information, change, and political agency.

As the relay hands off to designers, it is that interplay that is the subject of design. As mentioned in the introduction, designers who have begun to speculate and operate on global space, work with forms that do not fix position, but rather release agency or get things moving. As the word form moves through culture, it can describe many things from shapes and outlines to conceptual markers. But here, forms orchestrate an interplay between forms. The form is *interplay itself*. The form is an action. The action is the form. Like a calculus function or the delta in a mathematical formula, an interplay offers limits and behaviors.

Like the differential in a car, it offers a set of interlocked gears that transpose one potential to another. The form is a change and the means to make a change. It is a theater of operations and actions—an explicit set of interdependencies that set up new potentials within the organization.

Designing interplay, previously likened to playing pool, might also be likened to the housekeeping and bicycle riding mentioned in this discussion—responses that exist in culture's common sense or muscle memory. The activist designer is not designing a thing, but rather the means to engage, unwind, infect, hijack, or rewire an arrangement over time. They are adding a reagent to a chemical reaction, or the establishing a protocol to organize a sequence of code.

This interplay is not somehow evaporative or unreliable, because it is not a quantitative or a visual expression of master plans and buildings—because it is latent, unfolding, indeterminate, and environmental. Quite the opposite. It may be more sturdy and reliable precisely because of these attributes.

It is certainty that may be an impractical, even dangerous illusion of the modern mind. While culture theorizes or fantasizes about autonomy or steady states, to generate any form is to create disruption in a world that is already entangled from every scale and perspective—from the social to the chemical and atmospheric. As physicist and feminist theorist Karen Barad writes,

> All bodies, including but not limited to human bodies, come to matter through the world's iterative intra-activity—its performativity.
>
> … There are no singular causes. And there are no individual agents of change. Responsibility is not ours alone. And yet our responsibility is greater than it would be if it were ours alone. Responsibility entails an ongoing responsiveness to the entanglements of self and other, here and there, now and then.
>
> … We need to meet the universe halfway, to take responsibility for the role that we play in the world's differential becoming.[33]

Medium designers move through the world constantly jostling its solids into more interdependent relationships. In some ways, many of the examples of interplay that appear in the next chapters were there all along, but a fresh perspective only makes them easier to see or retune. The examples of interplay do not provide solutions or even a representative set of approaches. Instead, they begin to animate the world, leverage changes, and get the pieces moving around in ways that nourish a design imagination.

Maybe medium design can contribute to this rich interdisciplinary conversation by modeling explicit practical techniques within urban space. Working against automatic expectations of equation, proof, master plan, or completed object, it can organize some explicit, deliberate, but unfolding organs of interplay that exercise their activist capacities in social, political, financial, and environmental economies of space.

While continuing to call on more and more thinkers, the next chapters and interludes consider how medium design might address some contemporary cultural dilemmas. One considers an interplay of, not only financial values, but also situated spatial values within populations of dwellings that have often fostered inequality. Another looks at a switching interplay between automated mobility, transit, and other heavy spatial attributes in space. Yet another presents an interplay of failures and problems that might begin to address the dilemmas surrounding climate change. And, combining many of these concerns, the final chapter examines an interplay to reduce the violence of migrations at the intersection of inequality, climate change, and conflict.

Interlude Two

The Army-McCarthy hearings of 1954 were a watershed moment marking the beginning of the end for Joseph McCarthy and his fearmongering attempts to target communists through the Senate Permanent Subcommittee on Investigations. As the now-famous final straw is often portrayed, the Army lawyer, Joseph N. Welch, refused to engage an offensive line of questioning initiated by McCarthy, saying, "Have you no sense of decency, sir? At long last, have you left no sense of decency?" The courtroom erupted into applause, and in cultural hindsight, McCarthy was defeated.[1]

The change actually took shape over a period of weeks. There was already ample evidence that McCarthy's rancid tactics were dishonest and bullying, but facts made no difference to his means of exercising power. Welch, himself no snowy white angel, provoked McCarthy into the endgame position by deploying homophobic sentiments. Perhaps even more important than Welch's argument, the change was reliant on latent potentials related to the televising of the Army-McCarthy hearings. The broadcast served as a multiplier to expose McCarthy's demeanor and garner increased suspicion about him.

Years earlier, in 1947, the Hollywood screenwriter Dalton Trumbo appeared before the House Un-American Activities Committee (HUAC)—a committee that preceded the Army-McCarthy hearings but continued to function long after 1954. When Trumbo refused to provide any information to the HUAC, he was convicted of contempt of Congress. He served eleven months in prison and was blacklisted in Hollywood.

When he later wrote the screenplay for Stanley Kubrick's 1960 movie *Spartacus,* he was still writing under a pseudonym. Kirk Douglas's revelation that Trumbo was the author contributed to the eventual dissolution of the blacklist.

Maybe Trumbo was intimately contemplating the chemistry of political watersheds when writing *Spartacus.* In a fabled scene from the film, Roman authorities make what they portray to be a magnanimous announcement to a field of slaves who are shackled and chained to one another under the naked sun. The captives will all be spared crucifixion if they identify the insurgent leader named Spartacus. Given the number of slaves, there is every chance that they will be successful in squelching resistance and maintaining their powerful grip.

Kirk Douglas (Spartacus) stands in response to the request and is about to identify himself to spare his fellow slaves. But just as he is poised to shout, "I am Spartacus," Tony Curtis (one of the slaves) stands with him and shouts: "I am Spartacus." Then, one by one and in groups, more and more of the slaves stand and shout over and over again, "I am Spartacus. I am Spartacus." Laurence Olivier (a Roman general) looks on with concern.

By going to their death together, the slaves instantly turn the tables on their captors. Rather than handing success to an authority already preemptively congratulating itself on a successful strategy, they force that power to extinguish all of its human property.

The scene perfectly illustrates an interplay of actions in which lexical meanings and legal declarations—the name "Spartacus" and the guilt of an insurgent under Roman law —become less important than disposition. When the slaves say, "I am Spartacus," they tap into two resources: an inversion and a multiplier. By seeming to submit to or obey their captors, they satisfy the request, but when that submission is multiplied, it confuses and defangs the name and the power that uses it.

Crying "I am Spartacus" when Spartacus is not your name, and when the effects can be multiplied, is an excellent example of dissensus. It disrupts the modern mind's sense of order, its favorite way of recognizing names rather than activities, and even the position of names as evidence in the enforcement of law. The slaves know that the name that is so crucial to the Romans is evaporative and something that can be bounced around until it signifies nothing in comparison to the hard, physical facts of slavery. Just as the superbug confuses ideological labels, this activism in the register of disposition confuses, even dissolves, the authority and consensus of Roman rule.

Temperamentally, the slaves neutralize the violence of the authoritarian power and transform it into a brotherhood. The greater the cruelty inflicted on human property, the greater the chances that it can be converted into harm for those inflicting that cruelty. And the greater the chances that the entire group will choose solidarity because they have nothing to lose and everything to gain. Political bullies often make themselves a source of special favors to individuals in the group to foil this calculation and break up the strength in numbers.

The Spartacus moment is reminiscent of another similar moment of remission—the "no" campaign for the 1988 referendum in Chile that finally removed Augusto Pinochet from office. The referendum was to decide if Pinochet would stay in power for eight more years. After sixteen and a half years of a brutal dictatorship that tortured and killed its citizens, the "no" campaign might have portrayed fear and horror that could no longer be tolerated. "No" would then be an adamant refusal.

But the campaign chose instead to associated "no" with positive rather than negative energy. The "no" logo featured a rainbow and the television ads offered a goofy comedy featuring people joyously celebrating and looking into the camera with broad smiles. They wagged their finger with a silly version of "no" that really meant "yes." Music accompanied picnics, somersaults, collapsing walls, and bands of cheerful people

singing the lyrics "Chile, happiness is coming." It was a brilliant calculation that succeeded in outwitting Pinochet's hammerlock on power.

Precisely because so much global development makes urban space into spatial products or repetitive precipitates of financial abstractions, medium design can deliberately shape components that will act as a germ in these fields of repetition. Multipliers—like the multiplication of the name Spartacus and the broadcast of hearings or campaign ads—can be accelerants for interplays. Replicating products in contemporary space potentially strengthen the various regimes of capital that create them, but, as mentioned in the introduction, they might also be carriers of their own reversal. And when they contain inversions of meaning or expectation, they have extra powers of dissensus.

Chapter Two

Things Should Not Always Work

1.

Return to the explosive growth of the urban periphery mentioned in the introduction—the low-density territory that is growing so rapidly that it will approach the land area of India by 2050.[1] As more and more people migrate to cities and search for cheaper and cheaper land, development streams away from denser centers. This space is now a bellwether of both inequality and climate change—the space to which the disenfranchised are relegated, the destination of some climate migrations, and a settlement pattern that exacerbates climate trends.

A time-lapse mapping of Mumbai, Lagos, Mexico City, or Beijing starting at the beginning of the nineteenth century shows these cities maintaining a relatively stable land area for around a hundred years. In most cases, the first expansions of less dense settlement began at the start of the twentieth century, and by 1925, the land area of the city has quickly doubled in size. That steady growth continues into the middle of the century until it dwarfs the original core. After mid-century, the growth begins to accelerate exponentially—both exponentially larger and less dense. Toward the end of the century, the less-dense growth really skyrockets, leaving the original dense city as just a central dot in a massive urban formation.[2]

In that peripheral soup, consider the individual dwelling on a piece of land as a precipitate of inequality. On one end of the financial scale, the dwelling is aggregating and multiplying

as repeatable spatial product—the villa or the McMansion in polycentric suburbs. In his influential book *Capital in the Twenty-First Century*, economist Thomas Piketty measures the scope of global income inequality, and he demonstrates that, more than land, these sorts of dwellings have become a reservoir of global capital and a visible asset of wealth.[3]

On the other end of the scale, not a spatial product but a less privileged form of settlement proliferates, often without sufficient infrastructure to foster health and mobility. Sometimes called "informal" settlement or "autoconstruction," it is not without form, but its forms diverge from those used by the planning establishment.[4] These dwellings are sometimes even positioned directly adjacent to their more privileged counterparts, as graphic evidence of the extremes of uneven development.

While issues related to inequality and climate change steadily and rapidly worsen, two recent, well-intentioned attempts to grapple with the less privileged dwelling in this mix perfectly illustrate cultural habits—not only the habit of giving authority to financial terms, but the desire for the elementary particle, the new technology, or the radical manifesto. Once again, the comprehensive, quantifiable, emancipatory solution is irresistible.

Peruvian economist Hernando de Soto, long an advocate for the world's poor, critiques Thomas Piketty's leftist theories about inequality, arguing that they do not account for the vast amount of unrecorded capital held in less privileged settlements without customary land transaction.[5] De Soto would like to bring all these assets into what he regards to be a comprehensive capitalist system. He argues that those dwelling outside this system have been denied their rights to enter the free market, and that they should be given deeds to their property so that they can do so.[6]

Like many solutions, de Soto's program also finds a galvanizing new technology. Since many social and political challenges threaten to control or corrupt the registry of property for large

numbers of people who each own relatively little, assigning property rights might be seen as a data management problem. Given the lure of new technology, it is not surprising that de Soto and others would seize on the idea of a blockchain network—an encrypted, decentralized, self-securing ledger using a cryptocurrency like Bitcoin or its Ethereum successors.

A number of researchers and start-ups are experimenting with blockchain platforms as a means of accounting for properties and other assets of the poor because they promise to construct a corroborating trust network for all of the necessary bookkeeping. The MIT Media Lab's Digital Currency Initiative is working with the Inter-American Development Bank to develop an open-source registry for poor farmers to document verifiable assets of equipment. De Soto is working with a blockchain platform called Bitfury to handle property records in the Republic of Georgia. ChromaWay in Sweden, Bitland in Ghana, and Ubitquity in the United States also develop platforms for applications related to land.[7]

Yet for all its sophistication, some more primitive organizational dispositions can accompany the rhetoric of blockchain platforms as they claim to perfect economic liberalism with the escape velocity of libertarian thought. A promotional video for Ethereum, featuring a white-gray background and a centralized, pulsing, diamond-shaped logo, describes the ascendance of the platform toward Turing complete universality. Ethereum proposes to replace centralized finance, social networking, law, and governance with a multitude of currencies, communication channels, individual contracts, and "decentralized autonomous organizations." Everything will be distributed, ad hoc, individualized, and heterogeneous, except their own one, true monistic platform.

Another of Ethereum's promotional graphics presents the platform as a "frontier" in a cartoon desert. Encrypted against both security risk and interference from censorship, surveillance, or regulation, this massive platform for achieving

"consensus" must be allowed to develop with frictionless freedom to provide "universality, simplicity, modularity, agility and non-discrimination."[8]

Sharing a similar belief in the market, another economic theory offered in the recent book *Radical Markets: Uprooting Capitalism and Democracy for a Just Society* addresses the impoverished dwelling with ideas that are cousins of Henry George's late nineteenth century proposal for a single-tax system and William S. Vickrey's mid-twentieth century work on auctions. Countering the power of capital to hold and unfairly benefit from the ownership of land, George proposed to treat land as common property and tax its use for the benefit of all. Vickrey's Nobel Prize–winning idea about auctioning value within a pool has informed the practice of congestion pricing among other things. *Radical Markets* proposes blanket auctions to accomplish the same leveling justice that George sought.[9]

The book considers a community in Rio de Janeiro where all property—land, buildings, cars, equipment—could be held in common and rents to use all this property could be continually auctioned on smartphone apps until they stabilized at a fair price. In this "Vickrey Commons," all the rent money would fund "public goods" and a social dividend. The auctioning would "undo the tremendous misuse of lands and other resources. The highest bidder for the most scenic hillsides would never be someone planning to build rickety and dilapidated slums. The highest bidder for central city land would not be the developers of small, ritzy condos but the builders of skyscrapers for the new, vast middle class auctioning would create." Auctions could "save Rio—and the world."[10]

Radical Markets rejects efforts to address poverty with leftist notions of redistributing wealth, right-wing privatization and deregulation, or "technocratic" notions of international expertise with their targeted projects based on "randomized trials." Instead, with the enthusiasm of start-up culture, it harks

back to Adam Smith, Friedrich Hayek, and Milton Friedman and purportedly offers "the best method of large-scale social organization." The book continues to dream of the perfectly equalized dance of the market—recuperating economic liberalism and purifying a granular spontaneous competition that becomes a mechanism of "radical" egalitarianism.[11]

While blockchains or auctions might be useful tools, the translation of all exchanges into data exchanges or the comprehensive use of financial terms to assign value is also strangely regarded to be more rational and stable when it may be more precarious. Anthropologist and geographer David Harvey argues that a deed only makes it easier for capital to acquire those properties and banish the owner to another unsanctioned urban or exurban space.[12] Others are concerned that once these properties appear as financial assets, they can become the target of financial games—like the same mortgage-backed securities that caused the 2008 financial crisis.[13]

These solutions of economic liberalism are magnetized to the modern mind, and economic liberalism must continue to go through contortions to avoid its own paradoxes. It co-opts philosophical thought about individual freedom to support "free markets" that typically protect the freedom of one group at the expense of another. And a position that purports to sponsor multiple heterogeneous markets, and even a varied marketplace of ideas, pasteurizes its theories and markets to achieve a magic, universal solution.[14]

Leftist positions are also often in the grips of the modern mind. A sharp leftist critique exposes the paradoxes or illusions of economic liberalism—that, in its essence, it can never offer freedom, fair play, or benevolence. But the habit of declaring only one capitalist market—one ur-enemy to be defeated absolutely—is similar in disposition to de Soto's declaration of a single capitalist market. A leftist critique guards against collusion. You need not contribute to the violence and hegemony of capital or expect it to do good. But in advance of an ideal

scheme for *seizing the means of production*, how can design introduce extra, rival markets—especially spatial markets where value derives from arrangement and other physical attributes apart from finance?

2.

Skipping the romance with comprehensive solutions or ideological utopias, medium design simply encourages many approaches to interplay. Beyond any one metric—like a financial abstraction—a broader, more tangible portfolio of heavy, lumpy spatial variables, freighted with social, political, and environmental values, can be linked in interdependent relationships. Rather than anticipating certainty, a commonsense recognition of contingencies and situated potentials *should not always work*. Against expectations, indeterminacy makes this interplay more precise. And not freedom, but entanglements, make it more robust.

Political scientist and anthropologist James C. Scott joins the constellation of thinkers in Chapter One, adding a grace note to the interplays discussed in this chapter. In *Seeing Like a State: How Certain Schemes to Improve the Human Condition Have Failed*, he argues that imperialist high modernist planning schemes around the world—from Le Corbusier to Lenin—failed in part because they did not incorporate *mētis,* the practical flexible systems of knowledge that stand in contrast to "formal deductive, epistemic" knowledge. In an indirect echo of Ryle, *mētis,* as Scott describes it, is "variously called know-how (*savoir faire* or *arts de faire*), common sense, experience, a knack." Like others, he notes that the "acquired knowledge of how to sail, fly a kite, fish, shear sheep, drive a car, or ride a bicycle relies on a capacity for *mētis.*" Scientific engineering or universalist strategies obscure that important knowledge that "defies being communicated in written or oral form apart from actual practice." And Scott endorses "mutualism" as expressed

by anarchist writers like Peter Kropotkin, Mikhail Bakunin, Errico Malatesta, and Pierre-Joseph Proudhon.[15]

More important than determining an ideal arrangement or ideal modular building block is this *mētis*—the means to create some movement and interchange between the components of a spatial arrangement that may be suffering from its solutions. Multiple experiments can run in parallel and spin around different variables. Blockchains, the Vickrey commons, and randomized controlled trials might join countless approaches that foster entanglement. These mixtures of technique and approach do not signal compromise but rather enrichment.

The physical materials of the city—the human and nonhuman mixtures of house, infrastructure, and community that supports dwelling—come with situated values and affordances that can engage economic as well as environmental, social, and political ecologies. The relationships may be supported with data collection or indexes, and they can partner with or learn from the economic engines in any number of ways specific to the context. But the relationships exceed any one currency of exchange or ledger of values. Many affordances in space are made of activities or proximities that cannot be monetized. And the most sophisticated interplays may even sidestep the single modern author and provide forms for the participation of many authors.

The first designs of interplay—appearing in the next section of this chapter—offer specifications for linkage and interdependence between urban properties. They may propose reagents, mixtures, chain reactions, or ratchets that gain leverage incrementally.

Any interplay can also be gamed, corrupted, or capitalized; it will always go wrong. But different from a one-time solution, interplay is agile enough to remain in play and adjust to changing conditions or moments when it is politically outmaneuvered. The interplay may offer a temporary means to tune parts of the larger urban landscape, but by being impermanent,

it is not equivocal or hopelessly flexible—just more direct and deliberately partial.

And again, interplay, as an ecology rather than a solution, also offers some additional political advantages, expediencies, and accelerants. Spatial changes that do not always declare themselves or appear in lexical or legal registers can sometimes avoid ideological fights with an extra degree of political cover. You do not have to wait for the tabula rasa, the revolutionary overhaul of all systems, or the perfect renovation of political conditions. Some of these interplays might gain scale by piggybacking on repetitive components—from McMansions to the dwellings of autoconstruction—in landscapes that they intend to partially overwrite. In the greed to conquer space, the most powerful players may have conveniently provided the means to multiply a change and allow it to gain significant scale.

3.

Like episodes in an urban clinic, the following examples of interplay focus on the dwelling in urban and peri-urban space. Dropping down very briefly into different time periods and scales, the examples were chosen because they can proceed without master plans; they trade in heavy spatial variables that leverage financial abstractions rather than the other way around; and they create compounding value from the physical arrangement of these spaces. The array of examples is not representative, and it does not attempt to treat the complex issue of urban housing. Rather, it animates the effects of interplay between the components of dwelling and rehearses the practice of designing that interplay.

Compare the radical Georgist propositions above with practical workarounds of another Georgist, Ebenezer Howard—inventor of the influential garden city. Howard's *To-Morrow: A Peaceful Path to Real Reform* (1898), was a social and economic playbook for redistributing metropolitan populations

and wealth into the countryside. An interplay rather than a master plan, it outlined a means by which city dwellers could live and work in the country in healthier and less exploitative conditions. Edward Bellamy's futurist utopian novel *Looking Backward* (1888), Peter Kropotkin's cooperative villages, and George's single-tax system were all influences for Howard.

But Howard did not adopt the single-tax system. Temperamentally averse to conflict, he wanted to accomplish the same leveling of power without waiting for revolutionary changes to tax systems. He could more practically work with an existing landholding mechanism: the limited dividend corporation. The corporation would purchase the land and issue bonds, and it would be paid back by rents yielding but not exceeding an agreed-upon profit for the investors. Once the bonds were repaid, the renters became cooperative owners. Capital was a temporary means to generate value from arrangements—proximities to employment and community as well as access to green space. Those values and affordances, now sitting on the land, could be managed through collective ownership.

Howard's diagrams, like those that might accompany a patent application, expressed a time-released calculus of relationships. One diagram depicted the garden city idea as a magnet that gradually attracted a population from both the countryside and the city. Another diagram outlined what Howard called "The Vanishing Point of Landlord's Rent."[16]

As Howard's quite practical invention traveled and created a garden city movement, it often diverged from his intentions. Like all of these examples, the idea arguably went wrong. It was sometimes associated with pious, anti-metropolitan sentiment. Or its architecture dressed up in historic styles or other displays of false authenticity that were mimicked in the wealthiest suburbs. But for this discussion, the scheme for leveraging capital and mixing different ledgers of value is compelling.

Another example from the mid-twentieth century is more controversial. The *polykatoikìa* of postwar Athens constituted

a runaway form of housing that blanketed the city and accommodated large numbers of new city dwellers migrating from rural areas. The interplay was simple. A landowner agreed to donate their property to a builder and allow their house to be demolished. The builder paid for the demolition as well as the construction of a low-rise apartment building. The landowner got an agreed-upon number of apartments in the building in exchange for the original property. The builder sold off the rest of the apartments for a profit that could be used to finance another similar scheme on another property.[17]

For some, the *polykatoikìa* represents a predictable episode of distended real estate speculation. The form was responsible for the sprawling overdevelopment of concrete dwellings in the style of Maison Dom-Ino. The single-construction technology applied across the whole city was less responsive to, and even erased, some of the particularities of the city.

But for others, the *polykatoikìa* is a very suggestive improvisational form reliant on situated values and many bargains executed by many players. Building the *polykatoikìa* was also a form of *oikonomia*, or housekeeping. Families often allowed the structure to evolve and adapt over time, and even sometimes engaged in the construction process themselves.

The *polykatoikìa* has also long been the subject of design invention, since it is an engine of urbanism that gets pieces of the city moving. A design might piggyback on it and use it as a multiplier to carry a change across a population of dwellings. Or, any number of legal adjustments might serve as a governor of this engine to modulate or redirect it—to turn it on and off or adjust any of its parameters. The form inspires what historian Ioanna Theocharopoulou has called a "new *mētis*."[18]

Contemporary forms of autoconstruction in the urban periphery are often much more precarious. At a moment of intense urbanization and climate change, the dwelling that appears in sprawling suburbs or settlements may even be more important as a physical object than as an item in an economic

ledger. Impoverished urban settlements—often called slums—present a morphological as well as a political and economic problem. An urban clot of dwellings with no infrastructure makes mobility extremely difficult. Long walking distances or little access to transit makes travel times to work impossibly long. And physical mobility impacts social mobility. The typical remedy to this lack of infrastructure is often demolition and disenfranchisement to build large urban arterials.[19]

Global governance organizations like the UN have only recently formally acknowledged and analyzed the consequences of urban morphological and spatial variables.[20] And while all of this work proceeds by resolutions and consensus, relying on quantifications and metrics, it is notable that those metrics are measuring not only urban components but relationships between the components.

A pledge to study slums at the 1996 UN Conference on Human Settlements led to further data collection about cities, and in 2004, UN-Habitat began an analysis of the actual arrangement of cities. The eventual publication, "Streets as Public Spaces and Drivers of Urban Prosperity," scored sixty cities based on infrastructure development, environmental sustainability, productivity, quality of life, and equity and social inclusion." An additional Composite Street Connectivity Index of the 2004 study compared things like density of streets or intersections. The work has led to initiatives that improve streets in cities or insert them into low-density peripheral development as a means to deliver mobility and infrastructure.[21]

One of these initiatives addresses a number of conditions, including peripheral fabric with an interplay that recuperates the techniques of land readjustment. First used in Germany in the early twentieth century, land readjustment allowed farmers with irregular lots to trade adjacent fragments and regularize the geometry of their fields to gain more usable areas for farming. Germany has continued to use the technique; Japan used it extensively to convert a third of its built area; and it has

been used in some form in Australia, India, Indonesia, Spain, Taiwan, and Turkey as well.[22]

Real estate capital has arguably used conventional land readjustment exploitatively to buy out individual owners whose parcels might form part of a larger municipal project. But real estate capital is often the chief beneficiary in these cases. In a buyout, the seller is left with cash that depreciates in value, and the buyer is left with property that appreciates in value because of infrastructural improvements that are possible after land aggregation.[23]

But UN-Habitat and others are developing versions of land readjustment protocols that are self-financing, cooperatively directed by a number of participants, and reliant on a market of spatial values. In this version, owners allow their land to be aggregated and redeveloped with new uses, in return for a smaller portion of the property that will continue to gain in value. Calling the protocol "participatory and inclusive land readjustment," or PILaR, UN-Habitat is experimenting with pilot projects in Columbia, India, Angola, and Turkey that use this engine to convert urban land to new uses, insert infrastructures into compacted peripheral settlements, and reconstitute cities after a natural disaster or conflict.[24]

Any situation can become corrupted, but, with this form of land readjustment, landowners in a more precarious situation need not relinquish their property to a financial abstraction. Instead, a small group of neighbors pool land for a tangible project. The heavy values and affordances related to proximity, mobility, health, and safety are achieved through an interplay, and the new spatial arrangement is the source of value. For instance, a settlement underserved by infrastructure uses some of their collective land to add a street network that also carries utilities for electricity and water. Or a community with insufficient open space uses some of their collective land to add a park. Land readjustment might even take advantage of what urbanists AbdouMaliq Simone and Edgar Pieterse consider

to be "makeshift" negotiations that are already embedded in many dwellings of this sort.[25]

New arrangements can also reorganize to cope with changing environmental conditions like floods, severe storms, and wildfires. Properties can be densified and repositioned to avoid risky areas. Rather than encroaching on rain forests or jungles, landowners might also consolidate in denser developments near small cities and engage in enterprises that take advantage of the values immanent in sensitive landscapes—reservoirs of water and carbon, sites for research and tourism, and sources for new pharmaceuticals.

While there are many obstacles to achieving consensus and salience in land pooling, there may also be accelerants for this interplay. PILaR was used to rebuild neighborhoods after an earthquake in Bhuj, India, and the ordinarily lengthy process proceeded relatively quickly since destruction had already essentially neutralized or aggregated properties.[26] Similarly, climate risks aggregate and index properties in new ways, and they might even establish a timetable that government incentives can reinforce. Or a public offering of infrastructure to be inserted into a PILaR scheme may have an expiration date that helps to consolidate negotiations.

In the suburbs of wealthy countries, land readjustment can also organize interplay. One organization, Changing Ground, is proposing *cooperative* land readjustment schemes that buy out the assets of property owners and rebuild with greater density. The co-op owners may use intermediate banking organs, but the real value is not in the financial abstraction, but rather in the new arrangement on the land. And the original co-op owners are the beneficiaries of this new value.[27]

These land readjustment schemes can include additional assets—from parks to schools to urban agriculture to community scale energy production among many possible ventures. Increased density that delivers new real estate values also supports higher capacity transportation systems, more

energy-efficient buildings, and potentially more diverse neighborhoods. Since the changes occur in situ, the demolition of existing structures can even contribute to recycled building materials.[28]

A land readjustment interplay demonstrates how spatial assets can alter economic prospects and even address income inequality. Without risk to the initial investment, this sort of interplay can allow a modest neighborhood to completely recast their existing property. Like the "1 percent" who make most of their money from investment, land readjustment might allow many to escape the precarity of relying solely on wages. The inhabitant's situated value is their heavy portfolio in a spatial marketplace—a physical, tangible field of value.

Communities can also design an interplay that uses combinations of land readjustment and protocols like community land trusts. A community land trust is a nonprofit that assumes ownership of land in a community, maintains the value of the land, and builds on it for the benefit of a community. When homeowners sell their property, they retain a portion of the sale, while the rest goes back to the trust. Countering gentrification and encouraging stewardship, the trust insulates the community from the spikes and disenfranchisement that often accompany the acquisitions of real estate capital.

At least partially addressing the unfair monopoly value of land that Henry George hoped to abolish, a land readjustment interplay allows any participant to generate value in relationships sitting atop the land. Rather than assets being controlled by financial entities with varying degrees of regulation, an owner can physically contribute to the value of that arrangement with maintenance and care.

Land readjustment also models what might be called *compounding reparations* for disenfranchised or abused groups of people. Reparations, as a one-time settlement for an incalculable harm like slavery or apartheid, is akin to the exploitative use of land readjustment by real estate capital. Cash does not

appreciate in value like the newly aggregated land from which real estate can continue to profit. Similarly, cash cannot account for redoubling values that have accrued to capital from free or inexpensive labor over many decades.

Compounding reparations invert that bargain and deliver the kind of asset—like property or education—that can provide increasing value. The value can also be enhanced by any individual in myriad ways that do not have to thread themselves through a financial abstraction. Sometimes reparations have been falsely treated as a "gift" from the enfranchised to the disenfranchised. When that gift comes in the form of space or property, it is inevitably a remnant that the enfranchised are happy to discard. But should the compounding reparation come in the form of already occupied properties or lands, land readjustment offers some tools to recognize, reapportion or stabilize value and ownership. And it provides ways to reliably and continually add value to that asset.

4.

The examples assembled here only begin to uncover a wealth of different mechanisms that might be used in inventive combinations. There is no generalized interplay that can travel the world, but rather an approach to combining ingredients in many different complex contexts. As more examples of interplay appear in subsequent chapters, they begin to point to a larger inventory of approaches—approaches that mix spatial variables with all sorts of tools, metrics, and financial organs. These heterogeneous interplays mix the authority of "knowing that" and "knowing how."

But what are the cultural narratives that would allow these forms to travel in culture? They often do not adhere to the practices of the design professions or the planning bureaucracy. Observations about interplay in space have long been part of urbanists' working knowledge, but favoring only some forms

of precision, culture does not regard this work to have the authority of science or economics. More reassuring are quantifiable assessments. Analysis of the city is best received from economists or social scientists in the languages of law or data. Global governance also favors abstracted languages that do not present lumpy surfaces. Strangely, the simple exchange of heavy physical temporal values is somehow too tangible, durable, or visible to carry weight in decision-making.

Intergovernmental organizations and global consultancies routinely correlate any innovation to financial indicators. The language used in the last fifty years of World Bank reports reflects a move away from more concrete to more virtual markers of productivity. References to the physical (e.g., "timber, pulp, coal, iron, steam, steel, locomotives, diesel, freight, dams, bridges, cement, chemical, acres, hectares, drainage, crop, cattle, livestock") from mid-twentieth century reports have, in the twenty-first century, been replaced with references to financial abstractions (e.g., "fair value, portfolio, derivative, accrual, guarantees, losses, accounting, assets equity, hedging, liquidity, liabilities, creditworthiness, default, swaps, clients, deficit, replenishment, repurchase, cash").[29]

Still, social scientists now increasingly consider empirical as well as scientific assessments of arrangements, proximities, and other contextual conditions. Similarly, irrespective of the quantifiable health of an economy, economists can correlate the chances of successful mobility back to place and neighborhood—proximities to trouble, obstacles to work or education, toxicity of water or air, lack of family or collective space, insufficient or unsafe transportation, and inadequate health care, among other things.[30]

Moreover, some of the most innovative experiments in economics may inevitably rely on something like interplay as it is discussed here. The "randomized trials" critiqued in *Radical Markets* no doubt refer to the work of Nobel Prize-winning economists Esther Duflo and Abhijit Banerjee. Duflo

and Banerjee reject master narratives about "solving" poverty and experiment with randomized controlled trials to discover interdependent factors that impact a specific context. *Radical Markets* dismisses the trials as "technocratic" or imposed from above, rather than carried along by individual agency within the market. Yet while those radical solutions return to the one currency, the one multiplier, the one algorithm or quantifiable solution, randomized trials consider multiple situated values with no single elementary particle.[31]

For instance, Duflo and Banerjee wanted to test ways to encourage immunizations that counter poverty. Mothers might not have the time to walk all the way to a clinic only to discover that the nurse was not there. So the trial that Duflo and Banerjee devised combined the obstacle of the walk with the benefit of both extra food and longer hours from the nurse. Given an immunization clinic serving a number of villages in an area of about six miles, they discovered that parents were more likely to make the walk if there was a small incentive of a two-pound bag of beans. More visits delivered economies of scale. And the nurse, whose salary was already paid, was now continuously serving a greater volume of patients more cheaply and efficiently.[32]

Yet while the economist's randomized trials have garnered authority as quantifiable proof of effective tools, does their real value lie, not in the quantification but rather in the exercise of interplay itself? The terms chosen for the randomized trials are arguably based on tacit knowledge—on a hunch. It is not clear whether specialists would have to be dispatched to each unique context to conduct tests and provide proof of consequential factors—factors that would inevitably change. And, in a more grave critique, it is easy to imagine incentivizing all sorts of outcomes. But a broader metacritique asks whether the simple cross-referencing of relationships in a community—whatever those relationships might be—is itself productive. The act of developing interplay alone is changing outcomes.

If it is the architecture of interdependence and entanglement that is the real innovation in the approach, the know-how of urbanists provides another kind of commonsense clinical evidence. Some of those relationships deployed in the trial—like walking distance and clinic location, in addition to beans, vaccines, and nursing hours—are spatial. But protocols of interplay are not proofs, and they are designed not to fix an answer. Rather, they provide more security and plausibility by being *indeterminate* and able to respond to changing conditions.

And, as was mentioned in the introduction, while it is generally assumed that designers must wait to be approached by clients with sufficient capital to build, protocols like community land trusts and cooperative forms of land readjustment demonstrate that the opposite can be true. Value begins with physical arrangement, location, community, diversity, proximity to other components of the city, and relationship to landscape—all factors that many designers and inhabitants can continue to shape over time. All the relative positions of all the components in an urban network constitute its value—a value embedded in space. That it might be coincidentally monetized is less important. For the interplays considered here, it may even be the case that land discarded or neglected by capital has the greatest opportunity to acquire *design value*.

The construction of multiple markets of exchange—as many as there are specific contexts—counters some cultural narratives about a comprehensive system of capital that must either be defeated or entirely retooled. Design bends and inflects many sorts of markets and mutual agreements, and it trades many forms of value that may be embedded in spatial arrangement. Like the multiple, changeable stories and obfuscations of the superbug, this indeterminacy and entanglement is a source of messy resilience.

Interlude Three

The individual stories of Jane Eyre and Rosa Parks are all too familiar, even though the ability of both characters to occasionally move political mountains remains somewhat mystifying. They are arguably both medium designers often working in the register of undeclared and latent activity.

In the novel *Jane Eyre*, Jane manages, against all odds and within a relatively short period of time, to overcome the punishing oppression of Lowood School at the hand of its director, Mr. Brocklehurst. Jane never squares off against Brocklehurst, but in the course of the novel, the hierarchy is inverted, and Brocklehurst's power rapidly withers. He quickly slinks offstage, and his name is rarely mentioned again.

In considering the Charlotte Brontë novel, theorist Caroline Levine's recent literary analysis perhaps surprisingly references many of the thinkers considered in this spatial investigation. Levine's approach to form in literature is sympathetic to the design of form as interplay. Even Levine's brief reexamination of the word *form* and its range of historical uses—from "immaterial idea, as in Plato, or material shape, as in Aristotle" as well as its myriad disciplinary situations—exposes the problems with any narrow use of the term.[1]

Departing from both structuralists and post-structuralists, Levine does not classify forms, but borrowing from both Gibson and the design world, she recognizes their "affordances" that, however "latent," have some durability as markers. Beyond forms like a sonnet or a novel, Levine looks for wholes, binaries, universals, and rhythms in the composition of work itself,

in the social-political context it depicts, and in the social-political context it disrupts as a work of art. In another "gestalt shift," she is not noting the "*content of the form*" but rather "*the forms of the content.*"[2]

Several turning points in *Jane Eyre* rely on forms of interplay. These forms do provide certainty and fixity, but thinking back to the chemist, they establish potentials in different combinations. And like chemistry, politics is reliant on what things can do when they are put together. While she does not reference Jane Bennett, for Levine, politics or a "political ecology" resides in these "collisions." Using Latour, she also considers "networks" of interacting components to be forms. And referencing Rancière, she treats politics as "a matter of distributions and arrangements."[3]

Initially, Jane Eyre is in an impossible situation, with all power and authority granted to Brocklehurst. Direct defiance or the declaration of grievances would only decrease her power and increase the power of her oppressor. Struggling only tightens the noose.

But by activating an ecology of moves, none of which might draw undue attention, Jane gradually begins to create leverage and get the upper hand. She finds affordances in the most meager opportunities, even setbacks. She first becomes an excellent student and transforms the hardened discipline of the school into an asset for herself. And when Brocklehurst falsely accuses her of wrongdoing—an event that would ordinarily be considered a setback—she finds her opening. The accusation offers Jane a tiny bit of leverage. The harm done to her changes the chemistry of authority by prompting sympathizing dissent among the other young women.

Those multipliers of Jane's power become a political resource. Jane's temperament and stature are important factors when Miss Temple, Helen Burns, and Jane meet privately in Miss Temple's room. Jane calmly narrates a believable story in her defense, and Miss Temple amplifies that small potential by

contacting someone from outside the community who corrob-
orates the story. A gathering of the whole school to announce
that Jane has been cleared of all suspicion produces the neces-
sary volume of sentiment to overcome Brocklehurst. Jane Eyre,
as both novel and character, is a political actor. She continues
to find multipliers and cultural collisions, as the novel travels
in the hands of its readers through different times and contexts.

Although different in content, the story of Rosa Parks
in Montgomery, Alabama, in 1955, is similar in the way it
shaped cultural, infrastructural, and spatial dispositions. In
the "separate but equal" Jim Crow South, white suprema-
cists constructed a closed loop of power that squared off in a
binary fight against African Americans. Parks could not stand
in Montgomery's Market Square, where slaves were once auc-
tioned, and demand equality in legal or social terms. That form
of ideological activism would have been largely futile, if not
deadly.

Instead, while it took just as much courage, Parks activated
an undeclared urban disposition, and she shifted this potential
in the spatio-political matrix to break a loop without intensify-
ing a dangerous binary. At the bus stop near the same Market
Square, with the white capitol building in sight at the end of the
Dexter Avenue axis, she refused to move from her seat on the
bus. The activism took the form of an interplay or a political
ecology. It was in an active rather than a nominative register.
Rancière writes that those who boycotted "really acted polit-
ically, staging the double relation of exclusion and inclusion
inscribed in the duality of the human being and the citizen."[4]

As in *Jane Eyre*, Parks's arrest—an apparent setback—lev-
eraged an advantage and found a multiplier in the intersection
between the transportation company, her body in that potent
location, and her fellow black citizens. Her actions moved into
position 40,000 black bus riders and 300 cars to support a
boycott. In a church on Dexter Avenue near the capitol, just
down the street from this bus stop, Martin Luther King Jr.

catalyzed and amplified all these actions by using the boycott to inaugurate the larger civil rights movement.[5]

Activism of social justice and activism of disposition go hand in hand and are mutually beneficial. The civil rights movement relied on declarative oppositional protest, but it also relied on the precise interplay of corporeal and urban dispositions in Montgomery. Parks practiced medium design, and her performance was not limited to her words and physical movements that day. In terms of disposition, her activism set off a chain reaction of latent potentials that continued to unfold over time in cities across the country.

Chapter Three

Smart Can Be Dumb

1.

The driverless car mentioned in the introduction is just one precipitate of the contemporary obsession with anything "smart" —an obsession that epitomizes cultural habits associated with being right or "knowing that." Conforming to default modernist scripts claiming that newer is better, technologies must be successive rather than coexistent. And, at a moment of digital ubiquity, "smart" attaches to emergent, presumably superior digital technologies.

In perennial cycles of obsolescence and replacement, new infrastructure technologies have overwritten existing networks, no matter how sophisticated the incumbents may be. In a confounding paradox, when the modern "smart" discards or subsumes the previous technology for the new technology, it eliminates information in an attempt to be smarter. It is a closed loop establishing a new smart that, by definition, recreates the old dumb. Masquerading as more sophisticated, it returns to a more primitive disposition.

In the US transportation landscape, the same automated vehicle is positioned to lead another episode in a long-standing comedy of errors and cross-purposes. The mid-twentieth-century monovalent highway network replaced a much more finely grained rail network deemed to be obsolete. The false logics of traffic engineering sized highways according to statistics about volume of cars. But since adding a lane of highways only invites more cars, highways were doomed to both

continually inflate in size and never relieve congestion. And a morphology designed for long distances with few access points was dragged through a more finely grained urban fabric—a move that was used to justify racially charged slum clearance, disenfranchisement and segregation.

But, most important, the car was a multiplier with enormous scale. Apart from the elevator, there are few particles in the urban landscape that have reformatted so many spaces in the world—from highways, to urban and suburban morphologies, to the earth's atmosphere. And while reliant on a fuel that provokes military conflicts and destroys the planet, car manufacturing is even treated as a key indicator of employment and economic health.

The persuasion justifying this cycle of replacement was often about freedom—"freedom of the American road." Driving is a slow, dreary, and time-consuming chore performed by gripping a wheel and staring forward at pavement. But, at least in car commercials, it is stubbornly portrayed as a luxury offering speed and the sexy, liberating thrill of rounding curves on wet roads.

Modernist scripts about automated vehicles may engineer still more paradoxes, false logics, and myths of luxury. Automated vehicles (AVs) are projected to create a "mobility internet"—an internet of things in which synchronized digital devices attached to everything will finally make the stiff, spatial world fluid.[1] Again, replacing incumbent networks, new technologies will provide the right answer.

Autonomous vehicles are heralded as transportation's magic bullet or the means to perfect driving. In ideal projections of a fluid, smart, digital world, AVs in efficient platoons will save fuel, reduce emissions, and increase both productivity and accessibility.[2] Summoning a recurring dream of uninterrupted movement, AV simulations feature stoplight intersections where cars never have to stop and wait, but rather slip past each other in a perfect corpuscular flow.

These visions seem to be missing a simple calculation related to size and volume of vehicles. If AVs are sold like individually owned vehicles and used in lieu of transit, the number of cars will skyrocket, creating unprecedented congestion. Expand the size of every person in the commuter train or subway to the size of a car, and the congestion would even overwhelm the countereffects of carpooling and platooning.

As car companies have transformed to mobility companies, and as ridesharing companies have modeled other arrangements, it has become clear that fleets of cars are a better way to organize this new technology. A number of mobility experiments have also taken this form. The goal is to reduce what are called "vehicle miles traveled" (VMTs)—the number of miles traveled by all vehicles on the road. Organizing the AVs in fleets at first seems to drastically decrease the number of cars needed. And with no need to pay for the labor of drivers, AV fleets initially appear to reduce the cost of travel as well.[3]

But there is yet another boomerang effect. The decreased costs draw more riders and more congestion. Larger cities are already experiencing this increased congestion because riders are choosing the convenience of ridesharing companies. Congestion pricing and carpooling, implemented in an attempt to control that congestion, would again point to a need for a higher-capacity form of transportation, like transit.

If driverless cars increase productivity by allowing passengers to work while traveling, and if there is then less incentive to shorten the commute, AVs might also encourage sprawl, again resulting in more vehicle miles traveled. The dream of the autonomous ride might mean traveling for longer periods of time to accomplish more far-flung errands—like a slow network of horizontal elevators.

Whether or not AVs exacerbate sprawl, sprawl already exists. Even if AVs could be perfectly synchronized to function with optimized efficiency, they do nothing to change the widely dispersed itineraries of households in the urban periphery that

already rack up many miles of travel. Nor is there any mechanism in place to generate revenues for repairs and upgrades to existing highways that constitute the other half of this transportation network.

When the magic bullet boomerangs, the optimistic projections turn to more dire predictions of increased congestion, emissions, and sprawl—the smart vehicle stuck in a dumb traffic jam.[4]

But the modern response to this traffic jam is to look for relief in the next emergent technology. And within automated transport, the persistent dreams often involve things like futuristic flying cars and personal rapid transit (PRT). In PRT organizations, cars gang up to become a train, which then separates to deliver passengers to individual destinations. In *Aramis, or the Love of Technology,* Bruno Latour wrote about Aramis, a PRT system planned for Paris in the 1970s and '80s. Despite repeated failures of the technology, scientists continued to believe that it would work. Latour exercised his actor-network theory to demonstrate that scientists were considering only selected interactions that reinforced their preconceptions. Writing what he called "scientifiction," he portrayed the researchers as characters under the spell of a blinding romance with the technology.[5]

In fictions about the "smart city," the automated vehicle is also now a stock prop—a data-gathering machine for a world in which data is treated as the only information of consequence. Data is the language in which information *can exist*. It can be stacked and quantified like other metrics. It can support economic, legal, or technological variables that galvanize confidence. Computing software and hardware are treated as the carriers of innovation.

Possibilities for potential problem-solving and data gathering with the sensors of an internet of things is powerfully tantalizing as a chance to have the right answers about urbanism. Urban softwares attempt to explain complexity in ways that

reduce that complexity or make ownership of the city available to those who can pay for the data. In just one example, MIT's City Form Lab has developed an Urban Network Analysis toolbox claiming that "the complex built environment can be reduced to three basic elements": links, nodes, and buildings. This observation allows them to develop a number of metrics— the "Reach," "Closeness," or "Betweenness"—metrics that can assist in "locating a business, explaining traffic patterns or the value of land in different parts of a city."[6]

The smart city maintains the shine of the new, even though its software and devices may centralize information in a network that is more crude in disposition, and even though it may be used to compromise privacy and free speech. And artificial intelligence can automate this urban surveillance. It would be difficult to improve on many of the smart city technologies as tools to support more superbugs of authoritarian power, whether these are political regimes, mobility companies, or ambitious digital platforms like Amazon, Google, and Facebook. In modern dreams, a lumpy world threatens to "bog down" the purity or freedom of a technological advance. And while these dreams may promote the libertarian decentralization of power, they often concentrate power and control in yet another closed loop.

Even among the most discerning critiques of "smartness" in all its forms, the powerful modern fear of the old hat continues to hold sway. The critique must be a dark sci-fi dystopia, which is ideally accompanied by just a little irresistible newness or futurism. It must still demonstrate its currency in the new and be accessorized by digital platforms, popularizing social media, blockchains, or data visualization. Ideas will not burst upon the scene, take hold, or sell books unless they are portrayed as the lone, leading idea standing atop the high-altitude peak. Finally, it is so much easier to conform to a default desire for the "radical."

2.

In medium design, to consider only digital data as information is to exclude most of the information that a city exchanges.

Like the situated values discussed in the previous chapter, spatial arrangements embody actions and latent potentials. These social, economic, environmental, and political potentials constitute heavy information. Organizations of all kinds become more robust when they do not parse information with a single language, whether that language is lexical, digital, or mathematical. And they are information-rich because of the coexistence rather than the succession of technologies. Most prized is not the newness of technologies but the relationships between them.

Information theory and urban space have long been intertwined. But the default search for solutions or codifications has perhaps overwhelmed the wealth of possibilities available from this perspective. Consider a few historical and contemporary examples.

In *The Death and Life of Great American Cities*, Jane Jacobs attacked the planning bombast that replaced large swaths of complex urban fabric with highways and monovalent housing projects in the mid-twentieth century. She argued for granular inductive thinking about the city's "organized complexity"—a term developed within information theory and adopted by biological sciences.[7]

For Jacobs, master planning was often like a game of pool (pool again) where you only deal with statistical averages about how the balls will move rather than fully accounting for the dense complexity of all their interaction. She argued that as planning quantifies solutions, it discards the particular "unaverage" and "most vital" information as statistically inconsequential. Although they were not quantifiable, Jacobs thought that the city was composed of "unexamined, but obviously intricately interconnected, and surely understandable, relationships."[8]

Yet even as Jacobs critiqued one closed loop, perhaps her own prescriptive sense of the city as an "organic whole" made her susceptible to appropriation from other closed loops.[9] Both libertarian and neotraditional movements have co-opted her work. Perhaps most notably, the New Urbanism movement has adopted her as a mascot. New Urbanists have the answer to urbanism. Their congresses have adopted a somewhat dogmatic charter of rules and pledges. And, while considerate of urban relationships, their designs often advocate for historically styled urban fabric—information in shape and outline—as a means of carrying the important codes for urban interactivity.[10]

In another example, Christopher Alexander, a mathematician turned architect and urban guru, argued in 1965 that "the city is not a tree"—an arrangement governed by a single master-planning logic that organizes all components as branches from a single trunk. Instead, he observed the city to be a collection of interdependent interactions:

> This effect makes the newsrack and the traffic light interactive; the newsrack, the newspapers on it, the money going from people's pockets to the dime slot, the people who stop at the light and read papers, the traffic light, the electric impulses which make the lights change, and the sidewalk which the people stand on form a system—they all work together.[11]

But Alexander critiqued solutionist thinking by offering another superior solution—again trading one conceptual loop for another. For Alexander, the city was not a tree, but an overlapping branching network called a semilattice. His followers have been drawn into a somewhat spiritualized practice, guided by lengthy tomes and numeric calculations. Alexander's modeling of conditional relationships in space may have benefited the art of coding more than the art of urban form-making.[12]

But rather than trying to quantify or codify the organization or appearance of an urban arrangement, return to the

information generated in interplay. Referencing the logics of networks and circuits, social scientist and cybernetician Gregory Bateson also arguably looked for homeostasis in networks and regarded information as the elementary particle in a wholistic view of the world. But, it is important to note that he shifted the idea of information from the nominative to the active register when he simply stated that information is "the difference that makes a difference."[13] Information is not only a message in a particular language, or a mass of data to be stacked and quantified. It is not a thing, but the registration of change. It is not content but activity. Action is information.

Again placing information in an active register, Gregory Bateson argued:

> The concept "switch" is of quite a different order from the concepts of "stone," "table," and the like … [T]he switch is *not* except at the moments of its change of setting, and the concept "switch" has thus a special relation to *time*. It is related to the notion "change" rather than to the notion "object."[14]

A switch, like the differential gears in a motor, is not an object but a delta or a registration of change that constitutes information. That change can be present in the interplay between anything. Bateson observed that a man, a tree, and an ax are part of an information exchange.[15]

Similarly, while using digital tools in complex economic formulations, contemporary physicist César Hidalgo recognizes embodied information in networks of urban "solids."[16] Referencing Michael Polanyi, he insists, "Knowhow is different from knowledge because it involves the capacity to perform actions, which is tacit." Hidalgo looks for "the accumulation of information in solids, and the ability of matter to compute." He writes:

> [I]nformation is not restricted to messages. It is inherent in all the physical objects we produce: bicycles, buildings, streetlamps,

blenders, hair dryers, shoes, chandeliers, harvesting machines, and underwear are all made of information. This is not because they are made of ideas but because they embody physical order. Our world is pregnant with information. It is not an amorphous soup of atoms, but a neatly organized collection of structures, shapes, colors, and correlations. Such ordered structures are the manifestations of information.[17]

The idea of newness and succession may be quite dumb, and if the intention is to make cities more information-rich, newness forecloses on that richness. Even digital platforms themselves become information-rich, not because of essential singular pathways, but because of the presence of messy redundancies. Not homeostasis but imbalance, not fixed pools of information but mixtures of many species of information—including the physical, heavy information of urban space—provides a wealth of potential to disrupt culture's closed loops and provide a check on the power of digital superbugs.

Rather than declaring the digital to be a dominant technology of innovation, it is the space where technologies interact that may be the real medium of innovation. It is the interplay between technologies that generates information, and it is the quality of their entanglements that signals more or less sophistication.

3.

The following interplay considers switching between emergent and incumbent technologies in the transportation landscape. Like Bateson's switch, design within this vast spatial informational network does not attempt to fix, quantify, or codify. The switch is an example of an interplay that is deliberate with regard to its intentions to connect and to confound monocultures, but indeterminate about all the values that will pass through it over time.

The switch is like Polanyi's hunch, the cyclist's rebalancing turn, or the shot that the pool player takes within the entire complex of possibilities.

Without "knowing that", a switching interplay allows the designer to intentionally inflect an organization with some know-how about making that organization more information-rich. As mentioned in the previous chapter on latent activity, you can read the different potentials or dispositions manifest in two segregated networks as opposed to two networks that interact by way of a switch. And you can read the potential scale of any change to populations of vehicles that, as rampant multipliers, have formatted so much space in the world.

At several junctures in the projections about automated vehicles, the size or bulk of objects in space interferes with all of the spectacular projections about the technology, foiling the quest for mobility as autonomous and emancipatory. But rather than responding with flying cars, a non-modern response might look not only to innovative technologies but also to innovative relationships between technologies and urban space.

While typically vying to be the dominant platform that replaces all others, modes of transportation arguably work best in concert. Just as the greatest impacts of computing technologies come from the way they rewire social habits, the greatest impact of transportation technologies may come from the way they rewire cities.

Switching between fleets of automated vehicles and transit as well as between transit, automated vehicles, and cycling or walking creates some mutually beneficial interdependencies. Switching can rewire an existing transit station, it can sponsor a new architectural volume in urban space, or it can generate any number of intermodal nodes where passengers upshift or downshift between low-capacity vehicles and high-capacity transit.[18]

Consider a transit stop in the suburbs. It might have a low ridership for several reasons. Potential riders cannot drive their

car to the stop and leave it in a parking lot because it is needed for other purposes throughout the day. Or the train does not take riders to their final destination on the other end of the journey, where they will once again need a car. Faced with these options, a commuter might drive their car from door to door. If that commuter has a family, they would ideally have several cars and drivers to accomplish several such door-to-door journeys. If automated vehicles, even fleets of them, are used for these journeys, transit ridership would decrease, and automated vehicle congestion would increase, making both networks less viable.

But if that transit stop provides the means to switch between fleets of AVs, transit, and cycling, all three components become reagents in a chemistry that potentially redoubles efficiencies. At a point of switching, AVs and transit become more viable because AVs deliver increased ridership to transit, and transit delivers riders to mobility companies who already fear the waste of circulating empty cars. Fleets of AVs also serve any number of trips that would require a household to own multiple vehicles at rush hours.

In the morning, a suburban commuter can walk or take an AV to the nearest switch, upshift to transit, arrive in town, and walk or take another AV to the office. What had been a two-car household can use the convenience of AVs not to clog the highway but to get to the switch and upshift to transit for an even quicker, hands-free ride. Other family members can organize their trips to work or school in a similar way.

And, on either end of the trip, any of these riders can arrive at a switch and downshift instead of upshift. The commuter can take a bicycle from an urban switch to the office or, on the way home, change clothes at the switch and jog or cycle the last mile home. The switch close to home might be in the commuter rail station, or it might be a smaller neighborhood substation.

If these switches are also generous urban volumes that concentrate errands and busy itineraries, the whole assembly begins

to finally reduce emissions, sprawl, and vehicle miles traveled. The switch is potentially more convenient if it responds to the intensity of morning and evening rush hours and consolidates primary repetitive trips—the place for food shopping, exercise, lessons, sports practice, day care, and school. Each activity provides sustaining foot traffic for the others. Parents ride facing the children they picked up from school or day care. Even those accustomed to door-to-door travel might find new efficiencies in cycling home armed with dinner.

Mobility researchers already favor a diversity of particles in streets and places of passage—buses, cars, AVs, bicycles, and pedestrians—because it is that *mixture* that begins to generate more convenience. In that light, a single low-capacity car as a mode of transportation, while associated with speed, is actually slow and retrograde. Mobility is not about the autonomous freedom of individual rides but rather about capacity, access, speed, and other pleasures of entanglement.

Because the car has been such a powerful multiplier, switching may have other ramifying effects on the shape of cities and suburbs. The household that previously needed two or more cars now potentially needs no car. The car formatted the suburban landscape, generating wide roads, large turning radii, driveways, and twenty-by-twenty-foot garages attached to each house. But a switching interplay has the capacity to shrink hard surfaces and eliminate the need for garages. Land that was once hardscape can be put to different uses, and houses can be revalued for reusable square footage. The neighborhood also now has a new component—a switch within walking or biking distance from every house that can contain a number of programs to serve households. And automated vehicles might be passing through cities with less traffic or parking and more green space.

Switching might also address inequality, race, disability, and other cultural divides embedded in urban space. Transit systems are typically routed to serve more affluent neighborhoods,

meaning that travel times for those who live in poorer areas are too long on a good day and impossible on a day with other difficulties. But AVs can travel anywhere to penetrate areas underserved by buses or light rail. They can streamline the really difficult transfers and wait times that some commuters currently face. And if the switch takes the form of a physical space, it can be a more robust and inclusive place for the cultural mixtures that generate diversity as well as social and economic cohesion.

Beyond the possibility of reducing congestion, emissions, and sprawl, this interplay demonstrates the potentially dramatic impact afforded by a shift in relationship rather than merely a shift in technology. Interplay alone suddenly alters many spatial landscapes and transportation potentials. If the interplay between AVs and transit delivers sufficient volumes to create economies of scale, a chief marker of inequality—the cost of mobility—is potentially redressed. And the interdependence between private mobility companies and public transit delivers revenue to public coffers for transportation services, maintenance, and innovation.

Even now, vehicle fleets of the ridesharing economy might rehearse switching organizations with the view to better transitioning employment and liability as mobility is automated. With its concentration of businesses and services, the switch might compensate for lost jobs in the taxi and ridesharing businesses. While there are many imponderables about automation and liability, with switches and vehicle fleets, liability issues at least resemble familiar forms, like those for trains and elevators.[19]

By concentrating businesses and errands, the switch can be a public institution, but it can also be a real estate organ. With real estate revenues from its train stations, Japan Railways Group, for instance, has been able to impeccably maintain and upgrade its system while also funding research and development in technologies like Maglev trains. Transit organizations

around the world are sitting on large amounts of land that is only used for parking, but AVs require much less space. Transit stations make some money from parking, but if that space can be converted to the space of a switch and filled with retail and business opportunities, it can return much larger revenues to support desperately needed maintenance as well as other transportation innovations of all sorts.

But imagine how it will all go wrong, as it surely will. It is not difficult to see how the switching configuration could even lead to a refreshed, super-insulated superbug.

Imagine toxic hybrids of real estate engines and utilities—massive accumulations of power and data, surveillance nightmares, and stratified forms of service like the fast lanes proposed for an internet that abandons net neutrality. Infrastructure histories—related to everything from rail to hydroelectricity to broadband—are filled with stories about networks that might have provided greater access and mobility but were instead strangled with choke points or monopolies.

While switching organizations could surely be gamed to facilitate this abuse, they also potentially establish interdependencies that might act as checks and balances against concentrations of power. The introduction of multiple players and forces into the equation means that it cannot be exclusively parsed by data or money. There are other solids and forces that productively throw sand into the machine to generate safeguards against comprehensive control.

One major source of counterbalancing or leveraging power over real estate or mobility companies is ridership—large populations of consumers and revenue for improvements—that only transit can deliver. It is not just that a public entity might have the upper hand or that the arrangement might be a more transparent way to maintain crumbling highway infrastructures and bring transit up to global standards. Like the cooperative land ownership that found value in a spatial relationship, the switch can be a powerful spatial engine or differential that organizes

capital and politics rather than the other way around. And it has amplifying effects that give it scale.

With powers beyond the master plan or solution, an interplay can also introduce a *changing* set of checks and balances. A network of switches can be constantly adjusted, like dams in a fluvial network or circuits in an electrical network. Like the relentless superbugs of power, interplay, in its extended temporal dimension, can evolve partnerships and bargains with any number of players.

In this medium design exercise, switching is not like establishing a single thing or a one-time solution but is, instead, like orchestrating an activity or inserting a delta that influences how many things will change or interact over time. It is an approach to interplay between digital, spatial, and human networks that potentially offers more information, choice, and equity. It is not about fixing positions but, rather, releasing relational potentials. The outcome is indeterminate and unfolding. Still, with deliberate intent and explicit means, it is possible to inflect potentials in urban circulation spaces.

Switching configurations can bring together many strands of infrastructure while consolidating destinations, fortifying ridership, fostering diversity, and organizing investment during a transition in transportation technologies. The switch is carried in a spatial medium that can change dispositions without declaring its political leanings. Without waiting for the legislation of ideal political circumstances, it can silently work to counter inequality and climate change. If medium design is something like playing pool, the current array of transportation circumstances—already unsustainable—presents opportunities to take a shot.

4.

Since persuasions about autonomy and freedom in transportation are deeply ingrained, designing the cultural narratives that

accompany the entanglements of switching may be especially important. But in a world that largely relies on visual evidence, how do you communicate the activities of a differential or a switch that resists representation? And in a contemporary culture that associates innovation with new digital technologies, products, and software platforms to be packaged in start-up clichés, how does medium design demonstrate that *a spatial relationship* is the innovative invention?

Some visions of the new mobility landscape are remarkably anachronistic. Emotional music accompanies an ad for a Renault concept car called SYMBIOZ: four people ride facing one another in an AV that is the family car. They are having fun. There is a passionate kiss between a man and woman in the car, but there is also a teenage girl and a younger brother. The AV is all alone on a wooded road that eventually becomes the driveway to their secluded modernist mansion. The car enters the house, doors open, and, with the ease that attends privilege, the four pile into the house. The teenager transfers her phone-watching from a seat in the car to a seat on the couch in the spectacular house. Meanwhile, the car ascends in a car elevator to be displayed on the roof as the camera pans up to an aerial view of the house in a green clearing surrounded by forest.[20]

Elon Musk—inventor of PayPal, Tesla electric cars, SolarCity, SpaceX, and Hyperloop—is transparent about his storytelling. A recent SpaceX launch sent into orbit a cherry red Tesla Roadster convertible driven by a space-suited mannequin with the radio playing David Bowie's "Space Oddity" because, as Musk says, "silly and fun things are important."[21]

Hyperloop, like another flying car solution to congestion, proposes to shoot pods of freight or passengers at supersonic speeds on a cushion of air in an underground tube. It is projected as a link between Los Angeles and San Francisco, even while a high-speed rail project is underway between the two cities. The first underground tube, dug by a company that Musk named "the Boring Company," is already deemed to be

slow, even with test cars, and it would be impossibly congested in regular traffic. But, with start-up swagger, Musk describes the project as a way to "revolutionize cities and get rid of soul-destroying traffic."[22]

Other narratives circulating in the transportation landscape are more insidious. Using the old superbug trick of co-opting and inverting an ideological message, oil company lobbies in the United States often oppose funding for transit, perversely spinning it as an unaffordable luxury of big government. Automated vehicles alone are the future of transportation, they argue, as they look for their own big-government funding to repair a crumbling highway network. In a stunning example of the trick, the oil billionaire Koch brothers funded a group called Americans for Prosperity, who likened light rail to the "diamond-encrusted Rolex watch" of transportation.[23]

Against all odds, superbugs can maintain an audience for these tired persuasions. It does not seem to matter that the disposition on the ground is wildly different from the story. Superbugs attach the idea of a corrupt, self-enriching luxury to the transportation networks that most broadly serve the public, while they attach the idea of freedom to a form of transportation that traps its riders in traffic. Fire and water may be licking at the tires, but drivers will still be facing forward, gripping the wheel, and listening to the theme music of soft-focus car commercials.

An ideological activist can fight against these attitudes about energy and mobility by protesting environmental deregulation or advocating for a retightening of emissions standards. And it is crucial that legislation cuts fossil fuel subsidies and incentivizes alternative renewable energy sources. Those initiatives can continue to work against concentrations of power that protect the status quo.

But activism that hopes to have compounding effects at a moment of climate emergency may need additional forms of storytelling that seem, at first, to run counter to ideological

goals. The switch is a spatial engine that potentially leverages capital to do something it does not want to do and does not know how to do: reduce emissions, sprawl, and vehicle miles traveled while increasing diversity.

Cultural narratives might have to entice these companies by playing on their own greed. Oil and mobility companies lobbying against transit in favor of loose organizations of AVs are arguably proposing to kill the golden goose. Rather than hoping that oil money's own big government will fund more highway space for heavy, low-capacity cars, or rather than trying to steal crumbs from transit budgets, the most self-serving mobility companies might spot the undervalued spaces lying at the crossroads of different modes of transportation. The overwhelming real estate capacities associated with these concentrated nodes of exchange may be excellent bait.

But it is also crucial to renovate the ways that culture characterizes innovation. Conference-room PowerPoint presentations, architectural renderings of the "money shot," and bureaucratic planning meetings do not work. Neither do upbeat start-up clichés, elevator pitches, and TED Talks, with their promise of rational problem-solving and jaw-dropping results. And designing interplay does not necessarily associate with preferred props of innovation, like new technologies.

Spatial variables and the indexes measuring *relationships* between these variables may be as crucial to global governance as law or policy. But what might be the persuasion for interplays that operate on latent potentials and should not always work? And how might they bypass official and professional customs to capture attention in popular culture?

Medium design has the difficult task of creating a taste for interplay. There are fresh aesthetic pleasures to explore in the adjustable, time-lapse changing of spatial conditions. The communications may be visual but not solely reliant on the visual. They may be cinematic. They may be another form invented for popular entertainment, like the countless videos that enthrall

simply because they record a process such as planting a garden, cooking a meal, or repairing an object requiring some practical know-how that unfolds over time.

With a sideways move into other forms of communication, if there is any hope of prying the individually owned car away from consumers, switching would also have to invert pop-culture scripts about the glamour, autonomy, and freedom with which cars are associated. The messages of car commercials have managed to create a contagion that has utterly changed the urban landscape. To overcome the sense that switching is a disruption to the dream of seamless travel, stories might portray it as a fresh desire—the pleasure and luxury of diversity and urbanity. However impure, this sly form of activism might still be a deliberate instrument to manipulate habits and routines in a way that has measurable spatial consequences.

Like the activists for Chile's *No* campaign, do transportation activists have the savvy or the stomach for designing these alternative soft focus ads. As the place that synchronizes the family errands, the switch might be a stage for relieved parents and emotional meetings. Or, switching may link to cultural scripts about exertion—cycling, running, or walking the last mile. The same muscular sexiness associated with ads for athletic clothing and equipment might be the ploy of mobility companies. Switching offers the seduction of facing other people or the pleasure of accomplishing something with your hands while in transit. Imagine the self-congratulation regarding not only personal but also environmental health. Working on all these fronts, the switch could prompt a story about a release from the slowness of autonomy into the speed and richness of entanglement.

Interlude Four

Shakespeare's *Richard III* presents another classic puzzle about runaway authoritarian power—another political superbug that somehow seems unstoppable. At the beginning of the play, against all odds, every obstacle seems to dissolve as the Duke of Gloucester ascends to the throne. No one stops him as he commits one after another thinly veiled murder to clear the way. One of the most implausible steps in this progress occurs in Act One, Scene Two. The duke encounters Lady Anne in a funeral procession to bury King Henry VI. Richard has murdered the king as well as the king's son, Lady Anne's husband, but he manages to seduce her within minutes. The scene uncovers some of the mechanisms that ensure the durable success of so much of the spatially embodied violence explored in this book.

Brute force and an immediate threat of violence at the first moment of the encounter is only partially responsible for Richard's success. Lady Anne is surrounded by all the gentlemen in the procession, and the duke stops its progress by threatening to kill anyone who does not submit. But Anne fearlessly protests and, with grisly descriptions, publicly declares that Richard is a murderer. Still, despite the strength of her resistance and her full-throated indictment, he is successful in conquering her.

Richard arguably manages not declarations but dispositions in this seduction. The facts about his murdering are repeatedly redeclared, but they make no difference to the ways that Richard will handle the situation. The world of declarative sense obligingly occupies only a portion of all the available

space of operations, leaving an overabundance of maneuvering room for those who know how to work with dispositions.

Richard does not have to prove his innocence or make Anne feel affection for him. Those are the levers of law and storybooks. By his own account, Richard is physically misshapen and unappealing, and Anne expresses her repulsion. It works to his favor that his appearance inverts all the normative, reasonable terms of encounter. Richard flatters Lady Anne, but flattery alone might have only made him more repulsive.

More effective is Richard's calm, almost submissive statement of being so smitten with love that he must take Anne to bed. By going too far too fast, he begins the shock, feint, and parry to provoke her and put her on the back foot. It is the drop of catalyst that transposes the encounter to an active register. Now, information will be carried in actions and disposition rather than in words.

Shakespeare, like any actor, is constantly playing with the discrepancy between the spoken lines and the action being played. Actors know how to speak the line "I love you," while playing an action that rejects love. Richard is not speaking his lines to accurately depict conditions in the court, but rather to activate and channel the energies of other characters to do his will.

Richard is speaking of love, but what he is doing is drawing Anne into a fight. Lady Anne is insulting Richard, but what she is doing is also running counter to what she is saying. Richard answers her back by adopting the rhythms of her speech. Anne picks up the same rhythms, and the speeches of both characters synchronize. As actions start to decouple from words, it does not matter that Anne is vilifying Richard. Declarative information is not important. The consequential information in this exchange is carried in actions, as Anne engages in an escalating back-and-forth with him. As is often the case when the superbug manipulates disposition, fighting is capitulation.

If Anne had also been manipulating dispositions, and doing

it quickly enough, she might have outmaneuvered Richard. She might have acquired a multiplier in the crowd of gentlemen who stood in witness. Or she might have put Richard off-balance by startling him with obsequious gentility or even her own attempts at seduction.

But Richard is already on to his next trick. Successful dissemblers often mirror and double their opponent by preemptively accusing them of the crime for which they themselves are charged. Because Richard is the murderer, he invites Anne to kill him with his own sword, casting her in the role of murderer that he occupies. With the blade positioned over his own heart, suddenly Anne appears to be in power.

But in the register of disposition, everything is turned upside down. Not only does fighting constitute capitulation, but while Anne holds the sword over Richard, she is really holding it over her own heart. She must calculate her own survival in the court. She is alone, with no husband or protector. Now, even the fact that she is surrounded by gentlemen plays into Richard's hands. Anne was not frightened to attack him when she first encountered him. But if she killed him with so many people present, hers would be the only murder that anyone actually witnessed. Those who had been wronged would be the only ones punished.

Richard deftly makes murder environmental—a surrounding medium from which it is difficult to escape. If Anne chooses to stay alive under Richard's powerful protection, then he has made her complicit in the same sorts of ambitions he had for himself. Again, in this inverted world, by not murdering, she becomes another murderer—another ally for Richard, along with all of those who stood by, watching. When she cannot plunge the sword, Richard finds the end of her argument and wins. The move to arm her disarms her. Anne also conveniently reinforces the observation that "being right" is not necessary being righteous, just, or innocent. It often means joining and reinforcing the safety of the closed loop.

Richard's seduction of Anne, although seemingly impossible, is not only easy for him; it is completely common and hardly a mystery. It is a scene played out repeatedly, even daily on the political stage. It is the traditional method for gaining totalitarian control over nations and empires, just as it is the method for gaining petty power in any puny hierarchy. But might it also model any environmental violence in which most of the players find themselves helpless to act with any conventional form of resistance?

Chapter Four

Problems Can Be Assets

1.

From the perspective of the political left, climate crisis and inequality present a clear and urgent reason to fight capital with traditional tools—carbon taxes and large public works projects like those outlined in the Green New Deal—that will redistribute wealth and enforce environmental protections. Rather than encouraging incremental and ineffectual belt-tightening among the smallest offenders, the left demands a radical realignment that legally enforces change among the biggest industrial offenders. If ever there was a moment, they argue, to seize the means of production and defeat capital absolutely, it is this moment of planetary crisis.

On the extreme right, superbugs again confuse and conflate ideology. The flimsiest stories can hold back mountains of distressing signals. In the United States, leadership has found remarkable success by echoing sentiments like those of Republican senator Jim Inhofe, who has long led a dogged campaign to convince the world that climate change is a hoax designed to "satisfy the ever-growing demand of environmental groups for money and power and other extremists who simply don't like capitalism, free-markets, and freedom."[1]

For many on the right, whether extreme or moderate, climate change is an impertinence that disregards the boundaries of nations—one of the prized inventions of the modern mind. Nonhuman chemical agency is also catalyzing the migration of humans who transgress these borders. Entrenched

political camps, with tragicomic bluster, retreat into ideological loops. Migrating people and suspicious chemicals in the air are enemies. But, contradicting its own ideological rhetoric, economic liberalism would nevertheless like to possess this capacity for free cross-border movements for their own enterprises.

Lying somewhere between the poles of a left–right political spectrum is The Breakthrough Institute. The group has drawn critique from the likes of activist Naomi Klein and art historian T. J. Demos, but it also once counted Bruno Latour among its senior fellows. Upbeat and seemingly untroubled by the arrogance of a self-reflexive Anthropocene, The Breakthrough Institute is a believer in the great progressive story of human technologies and their interventions in the world. Continued modernization associated with a liberal tradition is the answer to the climate change dilemma. Nuclear power and other new technologies are the means to "decouple" economies from ecosystems so that urbanization can concentrate development and encourage "rewilding" of the earth's surface.[2]

The Institute's manifesto, written in the language of a calming newsletter from a financial consultant, reminds its readers where power lies. The refined and insulating voice-over of the "reasonable man" suggests that everyone take a deep breath and believe in a long tradition. They write:

> Too often, modernization is conflated, both by its defenders and critics, with capitalism, corporate power, and laissez-faire economic policies. We reject such reductions. What we refer to when we speak of modernization is the long-term evolution of social, economic, political, and technological arrangements in human societies toward vastly improved material well-being, public health, resource productivity, economic integration, shared infrastructure, and personal freedom.[3]

In an article published in *Breakthrough Journal*, in 2011, Latour, endorses the position of Breakthrough founders

insofar as it refocuses attention not on an alienation from technology but rather on an interdependence between human and nonhuman factors in the environment. And yet while calling for this more informed balance, Latour seems to be drawn back into the same modernist traps he has critiqued. This new approach, he writes, can "modernize moderniza-tion" in a "postenvironmental" moment.[4]

Often, when dilemmas do not respond to pure political plat-forms or modern solutions, no sense can be made of them. This book opened with a list of these persistent failures and stalemates related to climate change as well as pandemic, race, inequality, technology, and migration. Markets continue to eliminate obstacles to profit until their subprime mortgages, offshore tax havens, and abuse of workers create a financial crisis or a wave of fatalities. Technological and quantifiable proposals, based on everything from statistics to big data, continue to galvanize decision-making, even when they come with internal fallacies. The apparatus of national sovereignty, new technology, and free-market autonomy continue to garner loyalties, even as they catalyze atmospheric processes outside of their controlling logics.

In the wake of failure many problems reside on the deficit side of the ledger. They can only be a sad embarrassment—something that is discarded, hidden, or left behind. Problems are dark things that must be overcome or exposed. The failure of migrations within a national logic of inclusion or exclusion leaves a trail of stranded individuals who can only be observed as victims. After industrial retooling or financial crisis, shrink-ing cities and fields of rusting industrial remainders are caught in a stalemate and are only good for ruin porn. Even culture's most productive industries only know how to melt down and recycle these objects—an adjunct of the very "heat, beat, and treat" technologies that created them. After a cataclysmic storm or wildfire, properties and infrastructures can only be restored to their previous inadequate state. Problems have no utility.

Perhaps with climate issues especially, familiar tragic plotlines shape the narratives. The solids and chemicals of human industry and environmental exploitation are usually surveyed as evidence of guilt to a soundtrack of brooding music. Given the polarized political scripts, there can only be good guys and bad guys, and nothing can be done until the bad guys are overthrown. Or, old sci-fi utopias or dystopias feature new technologies that are needed to rescue a discarded Spaceship Earth, escape to another planet, or enhance a human body with special powers to overcome the crisis.

Even as political purists accept nothing less than comprehensive solutions regarding climate, the issue also occupies intelligent minds with increasingly more precise measurements that do not necessarily promote change. And organizations that look to solutions and standards to contain problems and avoid failures may only foster the denial of information. Solutions present the logic of the loop. Just as the succession of technologies can be quite dumb, the elimination of problems can be equally dumb.

2.

Without diminishing the damage and misery of climate dilemmas that leave behind pollutants, scarred landscapes, disease, and ongoing conflict, might there be resourceful approaches that address these failures in different ways? Rather than searching for solutions to eliminate problems, medium design can treat problems as potent resources. Problems carry with them needs and experiences that offer valuable, heavy information and prompt productive interplay.

Parrondo's paradox is a counterintuitive game theory positing that if you play a game with a high probability of losing, you will lose, but if you alternate between two games, each with a high probability of losing, you can begin to generate wins. The resulting graph of wins resembles a shallow

sawtooth of incremental increases in numbers of winning games. And the process may actually behave like a ratchet—as if the losses create a kind of traction against which to make many small gains.[5]

Just as the newness of technologies may be less important than the interplay between them, the elimination of problems may be less important than the interplay between them. Problems may only remain too segregated. Problems from any quarter can leaven or catalyze each other.

Needs, problems, and even catastrophes can become resources. Like a valence electron in a reactive element, need presents a potential to combine. As Gregory Bateson noted, "zero is different from one," and its difference holds potential.[6] Going further, positive one and negative one are the same distance from zero. They both possess the same potential for making a difference. Setbacks like those in the stories of Jane Eyre and Rosa Parks offered affordances that could be converted to assets. One need can be a resource to another need. The failure that might create a negative value or absence of value in some registers still has the potential to productively interact with other potentials.

After Frederick Law Olmsted visited the Great Chicago Fire in 1871, he wrote about it in a short text for *The Nation*. He measured the space of the damage, the ways that locations previously separated by dense buildings were now available to one another, and the distance from which dangerous heat could be felt, as well as the distance from the epicenter to which people and objects were scattered in the aftermath. Studying fire presented the possibility of a new landscape with new separations, vantage points, and visual corridors that would even help to prevent subsequent fires.[7]

Soon after the successful expeditions to the North and South poles in 1909 and 1911, the forester and polymath Benton MacKaye identified an entirely different terra incognita. MacKaye, largely remembered as the regional planner

who conceived of the Appalachian Trail, was a truly eccentric thinker and visionary. In an article in 1925 and a book in 1928 entitled *The New Exploration*, he argued that man had used his technologies to chart and conquer the territorial limits of the planet, but now that entire apparatus had itself become a wilderness—an "industrial wilderness." Man, "in dispelling one wilderness ... has created another," MacKaye wrote. "For the intricate equipment of civilization is in itself a wilderness. He has unraveled the labyrinth of river and coast line but has spun the labyrinth of industry."[8]

MacKaye's terra incognita was made of grids for electricity and automobiles, as well as a collection of other lines of flow for goods and population migration. It was a "surface web," "a working thing; a rough-hewn organism—a system."[9] For MacKaye, this "wilderness of civilization" was a kind of geological formation, read not for its shape but for its recording of change and movement. Throughout his career, he treated this network like a fluvial or geological force with its own potentials and activities.[10]

Capital has long been indexing various conditions in the world that serve its needs, and controlling that territory irrespective of political boundaries. Tourism territorializes the planet according to water temperatures and the color of sand. Manufacturing industries colonize the world with free zones located in countries with the cheapest possible labor and the most lenient labor and environmental laws. The global agricultural industry indexes hours of sunshine and available water. The oil and gas industry indexes a resource under the earth's crust.

Consider an alternative indexing of the world that, like Olmsted and MacKaye, takes stock of the remainders and remnants—even the perceived failures of heavy industries as fresh resources in another ecology. While not new, these interplays continually generate emergent or underexploited relationships to mitigate against climate damage and violence.

Working with the leavings and detritus of destructive capital would seem to be a capitulation—a submissive position that backs down from the fight for justice just at the moment when only the most sweeping changes to the economy have a chance of countering climate change. Here, it would seem, is just another example of incrementalism.

But if it is crucial to begin a transformative process immediately, and in advance of overcoming a very durable political impasse between left- and right-wing ideologies, there may even be an expeditious political advantage to designing an interplay of problems. As examples of interplay accumulate in this book, they often set aside a comprehensive approach, that, in its purity, creates greater delays and deadlocks.

Instead, as these interplays develop an imagination about multiple terms of exchange and a heavy portfolio of spatial values, they are often trying to more quickly locate resources and values in problems. Whether related to land readjustment or switching—resources may only be available for interplay through failure. Spatial assets are released from financial markets and financial abstractions so that they can be valued in different terms. Land readjustment becomes viable when a physical arrangement fails to deliver the necessary infrastructure or fails to reflect the full value that might benefit its inhabitants. Or failures of transit and failures of new transportation technologies to reduce congestion or deliver mobility, when combined in a switching protocol, deliver ridership to each other to become more viable.

Again, design, usually seen as having to wait on either the defeat or the indulgence of capital, may have material that is not only immediately available but also in abundant supply. And with the same resourcefulness of the superbug, design can work on many fronts. For designers, as crucial as targeting and taxing the world's biggest oil companies is working behind their back on economies that offer fresh forms of readily available equity and employment to those of any ideological allegiance.

Can shrinking cities, floodplains, garbage gyres, or sprawling urban peripheries—with all of their alarming consequences in the form of fires, hurricanes, and thinning atmospheres—enter into new interdependencies with each other? Is it possible to identify a productive ecology between the very precipitates of political and environmental crisis? And does this interplay of problems have any chance of gaining sufficient scale to be effective?

3.

Now looking more cumulatively at previous discussions, the following interplays experiment with a chemistry between problems that can address, not only inequality, structural racism, and automation, but also climate change.

The valuable potentials immanent in arrangements are perhaps best illustrated when there are few resources that are valued in a customary way—even when there is very little, or even less than nothing, with which to work. If, like a ratchet, an interplay can gain leverage with a number of incremental moves, starting even from a need or deficit may make it easier to see the immensely fertile field of resources that are not part of abstracted or formalized markets of exchange.

In a number of pilot projects in poor communities, the NGO Asia Initiatives facilitates a dialogue in which communities get together to determine their needs and use these needs as positive resources—even a form of currency. The community assigns a credit value to a task or service that reflects the degree of need in a quantity of what are called "Social Capital Credits." There may be a need to plant a tree, clean up a waterway, paint a wall, take care of the elderly, or help with children's education.[11]

Performing any of these tasks earns the designated number of credits. Like blockchain tokens, the credits foil corruption because they cannot be stolen or used to buy merchandise

in stores. But unlike tokens, they are a series of actions that cannot really be monetized. They can only be redeemed for *more* things that the community needs—things like vaccinations, education, training, mobile phone talk time, or home improvements. A need is the resource as well as the material to be redeemed.

The business of corroborating and managing a simple ledger of these activities requires no complicated algorithm, because the entire community witnesses and acknowledges the change, and there is an online register for images and approvals of completed tasks. For every five credits earned by individuals, one community credit is banked in the community cache. The community can decide how to spend those credits for things like public toilets, schools, or street improvements. Outside aid is not only more effectively targeted, but its means of trading is actually already moving the material of an agreed-upon alteration.

Asia Initiatives is conducting pilot projects with Social Capital Credits worldwide—in Kumasi, Ghana; Kisumu, Kenya; and Washington, DC. They also have projects in India—in Madurai, Amravati, Dehradun, and villages in Tamil Nadu, as well as a project associated with the Mumbai-Pune Expressway. In the Madurai project, the polluted Vaigai River is divided into segments, and cleaning one segment earns credits. This environmental problem, broken into manageable tasks, suggests that even larger projects can be tackled with similar collective efforts.[12]

The next interplay reflects the know-how of designers who, with few resources or small budgets, have long been designing combinate interplays between problems in space. The Society for the Promotion of Area Resource Centers (SPARC), an NGO working on slum rehabilitation, engaged architect Rahul Mehrotra to help with their commission to design 300 toilets for the slums of Mumbai.

Public toilets present many problems related to gender,

safety, and timing. Women are often victims of sexual harassment and have special security needs when using the bathroom, especially at night, and they also have additional needs related to children in their care. Contractors who charge a small fee for the use of toilets increase the dangers by removing light bulbs to cut costs, and maintenance of the toilets is a constant issue for the entire community.

Mehrotra did not simply provide toilets, but rather designed an interplay between these multiple problems within a multistory building. Solar panels on the roof provide light and safety off the grid. The floor above the toilets serves as an apartment for the caretakers, giving them a stake in cleanliness and oversight of the facility. At no extra cost, the roof platform holding the solar panels can also be a space that is lit. Now not only a place for children to do homework, it is also a community gathering spot that, because of its elevation, provides visual relief from the claustrophobia of close quarters in the streets below.[13] At every turn, arrangement, linkage, proximity, position—all offering affordance or potential—were aligned in a more productive chemistry.

In another interplay, urban remnants and castoffs, when considered together, can form a reservoir of assets valued for attributes that are not always recognized on the real estate spreadsheet.

Nicholas de Monchaux's "Local Code: Real Estates" project indexed remnant properties in San Francisco and other cities across the United States. He saw all the empty, publicly owned urban lots as a new form of infrastructure that could be repurposed as a network. In San Francisco, more than 1,500 of these spaces largely correspond to parts of the city experiencing some economic or environmental trouble. In New York City, all the empty properties combined would be comparable in size to Central Park.

For De Monchaux, these remnant public spaces are not necessarily parks, but rather serve as a connective tissue, or a

"distributed immune system." He has called for land-banking them, saving them from future development, and creating a parallel market for noncommercial uses related to energy production, stormwater remediation, and sewer or electrical upgrades. Because these sites do not have real estate values, they make possible another market for trading and use, based not on econometrics but on spatial attributes that designers can inflect, improve, and combine.

Some shrinking cities are already bundling problems in interplays that take advantage of their many vacant lots. In St. Louis, Kansas City, Flint, and Youngstown—where those lots are often filled with heavy metals—Greenprint Partners can gain access to this land, leasing it on very reasonable terms precisely because it is damaged. The company uses the land for tree farms, specifically poplar trees that absorb heavy metal. The tree farms create jobs, improve the appearance and health of the neighborhood (financially and otherwise), create profit for the company, and remediate a potential property for the city tax base.[14]

Even though they have the capacity to deal with environment, expectations of a radical solution or a magic bullet may make the above examples seem anecdotal or insufficient in the face of climate crisis. In small ways, through some determined resourcefulness, and against all odds, the interplays manage to mitigate against overwhelming circumstances.

But if comprehensive solutions tend to concentrate power or reinforce left-right political binaries that throw up obstacles to any action at all, there may be other ways of achieving scale. Rather than fully *seizing the means of production,* or while awaiting the success of such an effort, the following interplay looks for scale not by colluding with but, rather, by reverse-engineering the market with a protocol for subtracting development.

A designer who wants to quickly remove obstacles to action might, again, look for a multiplier. The large volumes

of repeatable spatial products that have been the instruments of environmental abuse can be instruments to amplify change. Population has increased as rapidly in flood-prone areas of the United States as it has in areas with less risk, and some regulations meant to deter building in these areas have even been lifted.[15] Sprawling suburban fabric is also increasingly built in areas at risk of wildfires even as those wildfires become more numerous and severe.[16] In California, wildland urban interface areas increased by 20 percent from 1990 to 2010. In Colorado, the increase during the same period was over 65 percent.[17]

But combine these problems of risk and sprawl with yet another problem: the mortgage formula mentioned in the introduction that is responsible for the ever-proliferating single-family home. The American house that was the mascot of the global financial crisis began, in 1934, as a precipitate of the Federal Housing Administration's long-term, low-interest mortgage, invented to stimulate banking, generate construction jobs, and provide housing during the Great Depression. The government insured the banks against borrower default, and its guidelines encouraged bankable neighborhoods that were as uniform or as much like currency as possible. In the postwar era, so-called merchant builders got blanket approvals for thousands of similar floor plans all at once. Promotional stories about decentralization, homeownership, and patriotism were accelerants in this almost agricultural production of nearly identical houses.

Just as the mid-twentieth-century house became a contagion, it might also become a counter-contagion in the face of climate change. The 30-year mortgage, designed to reduce monthly payments now has a sufficiently long temporal dimension to collide with dire climate predictions. But perhaps against expectations, houses at risk of wildfire or flood might use their risk of financial and environmental failure as an *asset* to be traded. Leveraging risk can facilitate relocations of building

related to the effects of global warming. This exchange, even though it may involve the subtraction of building, can also address inequality, climate gentrification, and employment.

Simply rewiring the grouping patterns in any organization can alter its chemistry or disposition. As container shipment was taking hold, the double stacking of rail cars, first designed in 1977 and more broadly used in the 1980s, led to economies of scale that significantly reduced the cost of shipping.[18] Or, prospective kidney donors who are not a good match with a friend or family members now have a better chance of helping the recipient by entering into an exchange program that pools all the friends and relatives of all potential recipients.[19]

Now consider rewiring the ways that houses have been grouped. Mid-century US suburban mortgages were grouped, approved, and underwritten by the thousands for designs that increased bankability. Before the financial crisis of 2008, they were grouped again in bundles of subprime mortgages. But what if mortgages were rated not by financial abstractions, but rather by their heavy, situated environmental values, like proximity to transit or climate risks related to flooding or wildfires? And what if these mortgages could be considered and scored in pairs or groups that encourage, even accelerate, the contraction of development away from environmental risk?

Most of the information needed to score properties might draw from existing indexes of environmental risk, while also reflecting the additional intelligence of architects, urbanists, and environmentalists who can assess the changing shapes and contours of development. Some of these factors may be much simpler or more practical than obscure financial formulas, and they may offer more tangible risks and rewards.[20]

In one scenario in the risk landscape, the owners of House A are in a flood zone, facing unsustainable insurance costs. They must sell their house at a loss and move to House B. Usually, mortgage transactions are considered separately, but if the status of House A and House B are considered together,

and if the purchase of House B reduces collective risk (e.g., a move to high ground) the group of mortgages could be scored favorably.

Continue to play the game. The neighbors of House A— Houses C, D, and E—face the same increased insurance rate. They have to sell at a great loss. But if they form a group, and if the shoreline municipality buys the properties for the purpose of clearing and creating protective revetments or firebreaks, suddenly the vacated properties are more viable, and the collective score for the entire group increases. A vulnerability is converted into an asset that protects the whole community, and clearing land rather than building on land becomes bankable.

Fresh forms of vulnerability appear at the intersection of climate change and inequality. Those without sufficient capital to hold on to their property are typically subject to loss and attrition or regarded as blight that threatens the value of investment capital. They end up on the wrong end of the bulldozer. Now, in the face of climate change, wealth again has the capacity to purchase safety through relocation, elevated structures, or elaborate fireproofing.

But in this interplay, those who might be victims of climate gentrification can instead leverage that wealth to their benefit. If risk can be used as an asset to attract a buyer, a seller adjacent to the CDE group might sell to someone with sufficient wealth to elevate it and use it as a vacation home. The house's appraised value increases in light of revetments and a future unobstructed view of the ocean. If that house joins the group, the investment in elevation raises the collateral staked against risk and makes the entire group even less risky for the bank. By making groups, wealth is maneuvered into position as an offset and left to shoulder the inevitable risks.

In addition to decreased insurance costs that already incentivize each individual move, added incentives might be awarded for any risk-reducing score. Banks might be required

to waive origination points or other closing costs for mortgage groups offering environmental benefits. Other points of leverage might come into play as the game accelerates. If groups of three or four bring transactions to the same bank, the bank might provide any number of incentives in exchange for increased volumes of business.

If a move away from risk becomes popular because of its affordability, federal money may be freed to address climate change investment rather than buyouts. Currently, the Federal Emergency Management Agency (FEMA) in the United States incentivizes retreat from flood-prone areas with higher insurance rates or property buyouts. Other buyout programs are funded by state or municipal governments.[21] FEMA's first relocation of climate refugees, the community of Isle de Jean Charles, Louisiana, is laudable. But, at a cost of $48 million, it and other buyout programs may be difficult to fully fund, especially as more and more powerful storms, whipped up by global warming, hit coastal areas.

Small incentives with compounding effects would be much more feasible. Any state agency like FEMA might provide a one-time payment to the bank to increase the down payment or buy points to reduce the interest rate. A relatively modest contribution to a mortgage principal is then significantly compounded over the life of the mortgage. In a real reverse-engineering of the mortgage form, $1,000 can become $50,000.

In any of these scenarios, the unfolding interplay is something like an inverted game of Go that values clearings rather than walls. In the Chinese game of military strategy, players take turns positioning white or black "stones" on a grid to form defensive walls. But if clearings are valued over walls, the game is about staking out a reasonable clearing while also acquiring a spot on the surface area of that clearing.

Step by step, like a ratchet that works against an immovable weight, the active forms of a subtraction protocol can alter

populations of properties. Just as thousands of new suburban homes rapidly transformed the US landscape, these reverse-engineered multipliers might, in sufficient volume, transform the shape of risk areas, sensitive landscapes, distended suburbs, and other places where it might be wise to put the development machine into reverse.

Perhaps most important, anytime the construction industry is activated, whether to build or subtract, jobs are created. Instead of relying only on housing starts for construction jobs, the deconstruction of houses offers many other kinds of work tied to many industries. Deconstruction could have compounding effects, since the material harvested as well as the physical contraction prompts even more jobs related to everything from reuse of buildings to carbon sequestration.

4.

An ecology of failure offers some surprisingly powerful cultural narratives that come with their own camouflage. In addition to being expeditious, abundantly available, and a source of employment, failure, at least initially, offers nothing shiny to capital. The assets have values that are visible only to those for whom there is a match or a need. Like the Social Capital Credits, they cannot be stolen because they exist as a series of actions that can only be exchanged in a particular situation. Like any design, an interplay of problems can be exploited in unproductive ways, but initially, it offers a green light to get things moving.

Working with problems that have been discarded by the most powerful also has some of the scrappiness and resourcefulness of political tricksters—even superbugs themselves. Tricksters plead with their opponents not to give them the very thing they want until the opponent, hoping to offer punishment, offers rewards instead. By devouring toxins or problems as raw materials, such an interplay might defang

the opponent's powers. Rather than engaging and fueling a fight, the chemist of problems finds use in its byproducts—in the detritus left on the field of combat.

Useful are those narratives that find ways around the modern mind and its need to win ideological arguments. While a leftist critique is necessary to point out the traps and guises of capital, if, for instance, a Green New Deal fuels a need to defeat all other political ideologies and fly only under the flag of the left, efforts at climate change will remain in the old loops and binaries.

Would it be equally acceptable to the left to promote deliberately inclusive persuasions palatable on the left and the right —an "Earth shot" reminiscent of the space shot or an emergency retooling of industry not unlike the one in response to World War II? How do you establish a bold field of experimentation that relies on know-how rather than certainty. Even Franklin D. Roosevelt, expressing skepticism about economic theory, introduced his New Deal with a call for know-how: "The country needs and, unless I mistake its temper, the country demands bold, persistent experimentation. It is common sense to take a method and try it: If it fails, admit it frankly and try another. But above all, try something."[22]

MacKaye was among those providing New Deal ideas and, while perhaps far too prescriptive, the ideas came with that strong cultural narrative for a "new exploration" of the spent territories of industrial development. And this new exploration was not only an assessment but also a design project that relied on vigorously exercising an alternative imagination on the physical components of urban and regional landscapes. MacKaye's new explorer combined the talents of artist, engineer, and "scout" to "visualize." As crucial as actually manipulating these physical resources was seeing them differently or developing an ability to conceive of them as resources with their own repertoires and activities.[23]

In *Down to Earth: Politics in the New Climate Regime* (2018), Latour continues to wrestle with modern paradoxes. Like MacKaye, he too must emerge with a "new political actor"— "the Terrestrial, with a capital T." It would spoil the newness of Latour's argument to acknowledge a prefiguring thinker like MacKaye who also saw incumbent and emergent technologies as actors. Adhering to a modern habit even as he tries to dispel those habits, Latour replaces the Moderns with the Terrestrials. Using Donna Haraway's term "worlding" to "distinguish from the globe of globalization," Latour writes that the Terrestrial is "bound to the earth and to land, but it is also *a way of worlding,* in that it aligns with no borders, transcends all identities." He argues that culture has not inspired the Terrestrial because "ecology has not known how to mobilize on a scale adequate to the stakes."[24]

While there may be no need to declare a single new actor, as scout, explorer, or Terrestrial, most productive may be the narrative of exploration itself—the *environmental exploration* of changing conditions on the planet. As anthropologist Anna Tsing has written, "To enlarge what is possible, we need other kinds of stories—including adventures of landscapes."[25] Acknowledging an abundance of human-nonhuman relationships drowns out the perennial accounts that measure everything in terms of left-right political platforms or protagonists like *homo economicus.*

Imagine the heterogeneous stories of this exploration, offering metrics for economic, medical, and environmental health. Closer to a weather forecast than a stock market report, they would map interdependencies like the relationships between cold front and jet stream or COVID-19 shut downs and the reduction of air pollution. Interplay within this heavy portfolio would feature a set of interdependent indexes measuring disparities in wealth, deconstruction jobs, densification, carbon scoring, emissions, sea level rise, and global warming among other indicators.

Harvesting failures of any kind mines a planetary geography of value different from the mineral values that have driven human industry and capital. A more-than-human shift in perceptions might simply perceive affordances in the interplay itself—in the activities of heavy components in this wilderness. A world brimming with problems is brimming with potential. Constantly renewed, it presents a raw and limitless field of value.

Interlude Five

While refugees were streaming out of Syria during its Civil War, ISIS fighters were traveling to Syria by the tens of thousands to be part of what could be called the first global digital teenage war. It was a war in which, not nations but people from all over the world, often with only their age in common, were drawn to the cradle of civilization to annihilate one another.[1] The number of recruits traveling to Raqqa reached a peak around 2015, and many who were concentrated in Syria were eventually targeted and killed in the larger Syrian conflict. But for a time, a cocktail of monomaniacal clerics, sexual repression, violence, adventure, love, duty, and a yearning to belong, mixed with the accelerant of social media, was especially potent and effective for the teenage mind.

Contemporary culture found it unfathomable that a teenager who seemed to be cheerful, accomplished, and fully engaged in Western consumerism would be willing to trade it all for the grisly activities of ISIS.[2] Three young female recruits from Bethnal Green in London—two of them fifteen and one of them sixteen—captured global media attention because their story seemed to defy all reason. The press and their families emphasized that they were straight-A students who like to shop, hang out, listen to music, and dance.[3]

Like a cross between a management course and an evangelical text, ISIS recruitment manuals encouraged relentlessly friendly one-on-one contacts. Recruiters described ISIS as an appealing form of heroism and humanitarian adventure within a loving brotherhood or sisterhood. They sent gifts like

candy, or pictures of fighters in Raqqa gently holding kittens or eating Nutella.[4] Surpassing irony, one powerful female recruiter believed to have recruited the Bethnal Green trio, Aqsa Mahmood, had amazing success with a "girl power" message.[5] And the social media delivery mechanism also had special powers. If a recruit rejected the call, the ability of social media to "unfriend" or isolate, together with the need to belong, pressured recruits back to the fold.[6]

Analysts speculate that all of these approaches were designed to make recruits feel that they would be a more "compelling person."[7] Teenagers were offered a starring role—as an adult and a hero—in the ultimate movie. GoPro footage from the front, together with films of beheadings, were professionally edited with computer graphics and Hollywood production values.[8] Alongside these ghastly practices of killing and destruction, the ISIS administration assumed a remarkably bureaucratic, managerial tone, with a branded identity in stationery and logos, contracts, infrastructure and agricultural initiatives, and even a corporate-style annual report.[9]

The story of ISIS recruitment is stupefying. But it may only seem senseless because culture has built no sense around it. Cultural labels related to Islam or Western culture will not help. The storybook histories and banal conventions to which the ISIS recruits conform—even while they tragically believe they are rebelling—will never explain their behavior. The world has always known how to send teenagers to war, but it has no stories to address this mystery.

Gregory Bateson tried to explain equally mysterious compulsions or addictions like alcoholism with some dynamic markers for temperament that operate in the register of undeclared disposition. For instance, he considered binaries where two entities were either in a "symmetrical" relationship with oppositional, escalating, and mirroring tensions (alpha dog vs. alpha dog), or a "complementary" binary in which one party was submissive to another (alpha dog and beta dog). While

complementary relationships may ease tensions, repeated sub-
missions can also contribute to increased stress. More reliably
easing tensions and stabilizing relationships were reciprocal
relationships in which the different parties shared the role of
dominance, occasionally letting each other win.

In Bateson's formulation, an addict or alcoholic exercising
willpower to resist drinking was setting up a symmetrical com-
petition with drugs or alcohol that led to escalating tensions.
Rather than being helpful, willpower was then a destructive
practice that exacerbated tensions. The fight of willpower
against drugs could only be relieved by assuming a comple-
mentary posture—relaxing and giving in to an episode of using
drugs or alcohol. Or, alternatively, in a seeming paradox, the
only moderately successful treatment involved was not a war
against drugs and alcohol but another sort of complementary
relationship—the submissive acknowledgment of powerless-
ness in the face of drugs and alcohol that is at the center of AA
(Alcoholics Anonymous) fellowship.[10] Against expectations,
what appears to be submission is a strengthening form of recu-
peration.

Again, just as in the scene from *Richard III*, when focused
on dispositions rather than declarations, a world of sense may
be turned upside down. At the center of both ISIS recruitment
and subsequent deradicalization may be not declared ideolo-
gies but rather undeclared temperaments. Signing up to fight
and perform the most unspeakable physical violence may have
less to do with ideological convictions or military strategies of
soldiers and nations, and more to do with vulnerable recruits.
To sign up with ISIS may represent a release from competitive
tensions related to xenophobia or other misunderstanding. The
recruitment process skillfully manipulates those consequential
temperaments—inclusion, exclusion, competition, tension—
to offer the relief of entanglement in one-on-one connections
offering fellowship and love.[11]

Chapter Five

Some Violence Does Not Happen

1.

Violence is customarily regarded to be something that is marked by a punctuating event. Military battles, gunshots, or explosions capture the attention of the most familiar histories. In a world favoring declarations, an event or a piece of evidence must trigger the workings of law so that its violence can be measured as crime or combat.

And history has its favorites. The fabled stories of ideological conflict—like the struggle between capitalism and socialism—is given plenty of stage time, perhaps because it can lead to military war. Vast changes in culture that result from markets, disease, new technologies, or arts are only allowed onstage for brief intervals. The story of the assignment of the radio spectrum, for instance, is likely to be a footnote to accounts of World War I and II. In the body of the text, military and economic theaters are the dominant settings.

History is also enthralled with itself. Documenting the human story takes place within a philosophical meta loop—a theoretical structure that overwhelms or rejects fresh information. When a political scientist and economist like Francis Fukuyama writes an essay titled "The End of History," he demonstrates the failure of history to describe its own persistent, common failures.[1] Historians may even spar with one another as they play with the same internal conceptual devices like a classic set of toy soldiers or a favorite chess set. Each historian working within the loop can only try to top the previous

generations of historians on their own terms. Theories that shaped thought continue to shape thought, not because they reflect unfolding evidence in the world but because, in a world of ideation, circular logics are more captivating. History is then an operetta with the structure of an Aristotelian tragedy that is constantly anticipating its endgame.

Meanwhile, some of the most destructive violence no longer fits into these historical templates; it has become environmental. Pandemics travel around the world without respect for political boundaries. In the United States, racism and xenophobia embedded in urban codes and morphologies are sources of sickness that intensify the lethality of a pathogen. Terrorism and espionage work in acephalous networks—an atomized military apparatus that ranges from conventional heavy artillery, to drones, to millions of small consumer electronic goods and platforms that facilitate surveillance, and social media. As discussed in the last chapter, climate-related destruction, presenting no clear enemy or front, resides in larger and larger organizations and territories with changing markers for the temperature, chemical composition, and movements of surrounding air and water. Migrations caused by this climate change, economic forces, or conflict also flow over national boundaries and experience violence of a different sort than that of wars.

Latent violence in organizations of all sorts may be difficult to see, especially when it is decoupled from the organization's advertised message. Facebook originally presented itself as a smart and fun-loving platform to connect broad networks of people. By providing this service for free, the platform reflected an early characterization of the internet as a democratizing force that made the world more information-rich through exchange. Able to tailor their communications, families and specialized groups could make those connections even more meaningful or instrumental for organizing everything from support groups to political activism.

But in the campaign to be dominant and capture as much market share as possible, Facebook and other platforms introduced a consequential binary. The "like/dislike" and "friend/ unfriend" filters—not just a reflection of social inclusion or exclusion—allow the company to sell data about trends and preferences. Likes can be used to exaggerate the differences between groups and sharpen the weapons of discord and hate between them, as they were in the 2016 election interference mentioned earlier. But, remarkably, debates about the situation continually return to conundrums over free speech rather than targeting the monetizing binary that artificially exaggerates that speech.

Or, consider the latent violence in a combination of climatic and economic forces. The rising tide due to global warming routinely races into the shallow floodplains of Bangladesh, displacing millions. By 2050, climate change will displace 13.5 million in Bangladesh and 200 million worldwide.[2] The displaced often migrate to Dhaka, to factory jobs in one of the free zones now notorious for having the cheapest wages—the bottom in the race to the bottom. In 2013, one of these factories, Rana Plaza, was the site of the worst industrial disaster in history—a building collapse resulting from other forms of chiseling in its construction and maintenance.

In cases of international migration related to disaster or conflict, there is only the equally violent logistical "solution" for detention—an abstract container or legal lacunae to erase the existence of individuals. For extended periods of time measured in years, there can be no exchange and no work, only waiting in a refugee camp. And the broken solution swells to make larger and larger spaces of detention that last for longer and longer periods of time.

Designers, artists, and even humanitarian organizations, it is assumed, will take up familiar limited roles adhering to national logics. Accepting a downstream assignment within a bad idea, they can only design new housing within the labor

or refugee camp, or arrange the physical plant of a border crossing. Artists can only produce an exposé that dramatically portrays the victimhood of the migrating individual.

Recent migrations have been especially polarizing, triggering right-wing xenophobic sentiments. Migrants inconveniently reveal the problems and contradictions within national sovereignty and "free" trade. The old loops and binaries prompt misplaced nativist arguments about threats to security or loss of jobs and national culture. Free zones—strange cousins of the refugee camp—have even been advanced as a solution for putting refugee populations to work without creating domestic job shortages.[3] It does not matter if these arguments about jobs are false. Nations continue shadowboxing within legal regimes that they have crafted for their own advantage. And in the absence of a murder or a body washed ashore, the nation is portrayed as the victim.

These and other gradients of potential violence may not reach the threshold of a single violent event. Indicating a like on a digital platform is not typically considered to be a matter of temperament. When, to remain intact, a nation houses refugees in detention facilities or segregated dormitories, the efforts are treated as neutralizing accommodations rather than sources of brewing tension. Exercising the free trade that empowers global corporations while disempowering labor is not considered to be a violent, even lethal, act. Nor is easing regulations on polluters, tinkering with mathematical abstractions to falsely value real estate, or fighting to win an ideological argument. But while it may seem unlikely, these situations, like many described in previous chapters, have an inherent temperament—a potential to instigate or relieve violence or conflict.

In all these cases, there are blatant imbalanced power dynamics, with their drumbeat of daily effects but often no dramatic visuals and stories. It is as if there is nothing to see in the suburb, highway, or refugee camp, and no way to tell the story. Without collapse, crisis, or overt clashes, there is no

evidence of the violence immanent in disposition. The bank must foreclose on the house. The factory must collapse with its workers inside. The workers or migrants housed in camps must die, or they must rise up and revolt. A wildfire or hurricane must destroy sprawling subdivisions. For the baby human, it is as if nothing is happening until the loud bang is heard.

Perhaps because there may be nothing to point to—no image, law, declaration, or ideological ultimate—a constant aggression may be undetectable or impossible to prove. Somehow evidence of potential violence, disposition, or temperament is less authoritative, consequential, or powerful than the most primitive forms of violence that are always able to draw attention. For many forces related to inequality, climate change, or migration, there is no story that analyzes the noneconomic, non-military chemistries of causation.

2.

Medium design works on the histories of things that do not happen. In an inversion of declarative histories that chart discrete events or transgressions of law, a focus on disposition enhances the ability to detect and adjust *latent* temperaments in organizations. Organizations have inherent capacities to include, exclude, nurture, or harm, even in the absence of an event or declaration. This violence does not *happen*, because it is ever-present as a latent property or an ongoing series of actions.

This history of "things that do not happen" is one of continuation, with no successive or superior knowledge, no telos, and no beginning or end. It relegates the stories of national and ideological wars to the footnotes. In the body of the text is a wealth of consequential social and technical detail that informs the chemistry of problems in all their combinations. The overt conflict that, it is believed, must be the driver of any narrative is asked to wait in the wings. Wandering out of the military and economic theaters, the narrative looks for another kind of air

or logic or anti-history, and evidence of temperament spins the story on different pivots in unexpected directions.

This alternative history might be structured more like an epidemiology or a branching set of thresholds and points of leverage, and it might be largely concerned with how to modulate violence in organizations by making them information-rich. The focus might shed light on why some political stalemates can suddenly shift in moments of metastasis or remission while others remain immovable.

Johan Galtung considers this "structural violence" to be anything that obstructs human potential mentally or physically. He makes distinctions between whether or not violence is personal or structural, direct or indirect, intentional or unintentional, manifest or latent, and whether or not it is physical or psychological or enacted with negative and positive influences. The detention of a migrating individual is not just a waiting period but an act that impedes potential for those individuals detained. A positive influence, like receiving the rewards of a consumer society, can nevertheless constrain individual choices and development. One group may unintentionally infect another with a deadly disease, or a form of structural violence might oppress by withholding rights to an individual.

For Galtung, expanding the conception of violence means that peace can also be more than just the absence of war. Peace has to signal the absence of structural violence as well. He asks questions about whether direct personal violence is sufficient or necessary to abolish direct structural violence, and vice versa. While the rising up of personal violence against structural violence is the fabled cure of the revolutionary, he considers a search for ways in which it might not be "indispensable." Galtung also asks whether it is possible to eliminate both direct and indirect forms of violence, or whether one or the other will always be present. While there were glimmers of possibility in nonviolent protest or diplomatic arms control, it might always be the case, he writes, that "the devil is driven out with Beelzebub."[4]

Rob Nixon extends Galtung's thinking and widens its range to consider other agencies as well as violence "enacted slowly over time." Galtung's theory, he argues, "bears the impress of its genesis during the high era of structuralist thinking that tended toward a static determinism." Slow violence can begin to account for the degradation of the environment and respond to both "radical changes in our geological perception and our changing technological experiences of time." Nixon also considers how the poor—who are disproportionately on the receiving end of the "bloodless, slow-motion violence" that often fails to capture the world's attention—are not given proper authority as witnesses.[5]

By considering other agencies and temporal frames, Galtung and Nixon join many of the thinkers assembled in this book who consider potentials that need not result in an event that can be witnessed. Ryle refers to the clown's performance as a disposition rather than an "act," saying that "it is not happening at all."[6] Bateson describes the switch as a change or delta rather than an object.[7] And Bateson also describes degrees of escalating or diminishing tension that are associated with different binaries—symmetrical, complementary, or reciprocal —as unfolding relationships or gradients of disposition.

As is clear from the interludes, the histories of latent temperament often stray from or even invert familiar plotlines. It is not just that organizations are saying something different from what they are doing. The oil company can produce an ad bathed in green sentiments. Richard III can plead his love. There are other inversions. As in the case of Richard's seduction or Bateson's descriptions of addiction, fighting can be capitulation. Alternatively, as in the *Spartacus* episode, what appears to be capitulation or submission becomes a surprising countermove to disarm a destructive force. Similarly, with addiction, relinquishing the fight may give the addict some traction against the disease.

Return to the parent with squabbling children described in

the introduction to this book. Rather than litigating the argument, the parent redesigns the physical and spatial human/nonhuman medium to blunt any prompts to violence. Their techniques are familiar and yet also maddeningly counter to the familiar scripts for ideological fights. In the same way that medium design can manipulate parallel markets of value, it can, like the parents, also shape the undeclared dispositions that may even be more consequential than declared political platforms.

3.

The following interplays explore organizations in which a shift in disposition and temperament is consequential. They revisit some of the medium design perspectives considered thus far—generating interplay rather than solution, entangling networks, and multiplying problems—with particular attention to moves that reduce violence in organizations. The final interplay looks cumulatively at the issues taken up throughout the book by focusing on the temperament of migrations related to inequality, new technologies, mobility, climate change, and conflict. But it alters those temperaments by treating migration as an environmental exploration like that discussed in the last chapter—a global mobilization that is unlike war and already underway.

The first of these interplays considers temperament in an exchange between digital and spatial networks. While they stage no overt or direct forms of violence, the symmetrical face-offs between hackers and the international security apparatus are fraught with tension. Fortifying against government intrusion, hackers fight to preserve open and private exchanges for free speech and dissent. But the security apparatus, like the NSA (National Security Agency) and its Five Eyes partners, takes a similar stance as warriors against cyberattacks.[8]

While both hacker networks and government security networks are extremely sophisticated, with abundant multiplicity and planetary scale, the temperaments that attend

them may be more elementary. Both the hacker and the state often assume symmetrical binary dispositions like those that Bateson describes, with their escalating tensions and mirroring behaviors. Each feel justified in spying on the other and encrypting against the other. Each claim violations of rights and freedoms. Each wish to draw into greater and greater realms of secrecy, even as they retaliate with publicized attacks against the other. Each flaunt their prowess—their airtight security or their media savvy.

In this oscillation between loop and binary dispositions, each side is the controlling force, and each side is the victim; each is on offense, and each is on defense. Both networks make a utopia of the realm they protect. The nation is pure and forthright, and it must be protected against unpatriotic acts. The hacker regards the digital world as a higher plane that holds out the promise of autonomy, and liberty, and forms polity unfulfilled in the heavy world.

The Tor network presents a case of shifting temperaments in relation to this standoff between hackers and government security. Tor encrypts emails by relaying them between routers. It is used by journalists, whistleblowers, and anyone else who wants to protect against government surveillance. While it received some of its initial development funding from the US government, it became an NSA target and was characterized as part of the "dark web" of criminal elements.[9]

In the aftermath of the Snowden leaks and one of the first rounds of Wikileaks, Tor, of necessity, squared off against government surveillance and was as intent on preserving privacy as the government was intent on preserving security. Both networks sometimes have the disposition of an all-channel, open web, and sometimes that of binary opposition. When in binary opposition to each other, the increase of security on both sides also increased the risks for both.

But the temperament of opposition shifted in perhaps counterintuitive ways when the Kilton Public Library in West

Lebanon, New Hampshire, publicly announced its decision to house a Tor relay. Kilton received a government security warning encouraging it to shut down the network. The library put the question to a community vote, and the community voted to restore the Tor relay.[10] The episode prompted the Library Freedom Project—a movement among libraries to ensure privacy on computers housed in public libraries. As members of torservers.net and the Tor anonymity network, the project educates its members about surveillance networks while embedding more relays in more and more public spaces and democratic processes.

Not unlike the *Spartacus* episode, Kilton Public Library presents another counterintuitive outcome from the realm of disposition and temperament. Kilton abandons the face-off with the NSA, and even as it increases the exposure of the network, it creates its own strengthening camouflage. Rather than freedom and autonomy, Kilton chose entanglement and anonymity. Or, recalling Bateson's thoughts on binaries, a reciprocal exchange eases the tensions of a symmetrical binary. Not a pure, untouched digital network but an entangled interdependence between spatial, physical, legal, and political networks—with mixtures of different species of information— invites users into more expansive, secure, and information-rich territories.[11]

Or, consider an interplay that modulates violence by rewiring potentials. The Avondale neighborhood in Cincinnati, Ohio, has one of the highest rates of infant mortality in the United States. The neighborhood is low income and largely African American, and it presents an especially severe case within a general problem. Infant mortality among African American mothers of any income or education level is higher than that of their white counterparts. Environmental forms of stress related to racism, as well as racism within the doctor-patient relationship, are possible causes.

Public housing projects in neighborhoods like Avondale have

historically concentrated and exacerbated poverty. Many were the result of urban renewal that wiped away a historic fabric with many different houses and owners, replacing it with a "solution"—mid-rise to high-rise buildings poorly managed by a single government or municipal agency. The violence resides not only in the destruction of the fabric but in the monovalent arrangements that, not unlike detention centers, reduce choices and urban encounters. In these environments, poverty and related issues of addiction and crime often seem inescapable.

But Avondale found a way to reduce infant mortality by finding an unlikely asset in the concentration of mothers facing similar obstacles. With the help of other community organizations, managers of housing nonprofit The Community Builders started a matchmaking program that linked mothers together in mentoring programs. The program pairs mothers with other women in the community who serve as their "health champion," providing guidance and support not found within professional health routines.[12] Like the kidney donor network that benefited from widening the pool of needs and rewiring the linkage pattern, a housing project, itself deemed to be a problem, became a resource within a newly designed ecology of exchange and proximity.

Another interplay considers the violence latent in any neighborhood that, because of racism or xenophobia, is consistently starved of health, welfare, security, and mobility. Imagine a community segregated and marooned by an urban highway like those mentioned in Chapter Three. Perversely, in the United States, the institution regarded to be the delivery system for that community safety and welfare is often another form of violence—policing that creates a carceral regime of the neighborhood itself. And when this violence on top of violence fails to reduce violence, the answer is, again, violence—an inflated prison system that almost becomes continuous with the neighborhood. This environmental violence surrounds and overwhelms the violence marked by any single event.

During Black Lives Matter protests that reignited and swelled in the summer of 2020, support galvanized around interplays for defunding or abolishing the police—proposals with sufficient rhetorical strength to locate the source of violence in the policing monoculture itself. They argue that state or municipal funds would be better spent on an array of integrated institutions and professionals delivering education, housing, health care, emergency intervention, and counseling among other things. Like the Social Capital Credits that make needs into productive ecology or like the green infrastructure projects that make jobs and revenue out of heavy metals and vacancy, these alternatives to policing become sturdy through entanglement.[13]

The final interplay, about migration as environmental exploration, synthesizes a number of components from interplays previously discussed. The last chapter described the environmental exploration of a terra incognita—the planet's remaindered technologies and environmental problems—with a view to designing productive ecologies between those problems. This chapter considers migrations of all kinds as well as a number of actors who have been floating through the chapters and interludes: teenage soldiers, Terrestrials, scouts, explorers, and activists.

Some of planetary mobilizations previously discussed embody dangerous temperaments, and the default temperament of conflict is all too easy. Climate change efforts are trapped in ideological binaries. Migration is regarded to be a crisis that triggers xenophobic rejection. And the Global Digital Teenage War too quickly converts young energy to the old wars of nations and empires. Even the response to the COVID-19 pandemic has been consistently likened to war.

But crucial to this discussion of temperament is discovering other attributes of mobilization that are not like war. Things like climate change and pandemic have no front lines or discrete events. The points of contact are environmental or surrounding, and the violence is gradient. COVID-19 has

allowed the world to explore the potentials—both destructive and creative—of shutting down the planet by restricting movement. Migrations allow the world to explore the potentials —again both destructive and creative—of turning on the flow the movement.

Considering temperament and a combinate chemistry of problems, can you design an interplay in the spirit of exploration or expedition that merges the migrations of conflict, inequality, and climate change to address these very issues? Since most migrating individuals are young, prompting fears about a lost generation, can a mobilization of the young be not-war? And if, above all, medium design is not about fixing position but getting things moving, can migration be a constant asset—not a crisis but a streaming mobile engine of environmental exploration?

The terra incognita in this expedition is a commons. There are common physical assets, like chemical atmospheres, that are difficult to territorialize, and there are problematic remainders that markets and nations discard. But there is also something like a "mobile commons" that Mimi Sheller writes about—a commons of relationships, activities, and movements as well as heavy objects and solids. Making "common" into an active verb, Sheller describes:

> a more mobile imaginary of the commons, or commoning, as a political action—and one which the contemporary moment demands. What if the commons were not just about the sharing of a territory, a space, a resource, or a product, but could also refer to the affordances and capabilities for practices of moving, traveling, gathering, assembling, as well as pausing and being present? What if we conceived of mobility itself as a commons, and the commons as mobile?[14]

Mobility, with or without travel to different locations, can generate rich exchanges that modulate conditions around the world. Moving upstream from the sharp end of migration,

before a moment that triggers refugee status, an interplay might break the loops and binaries of nations and markets by multiplying the one-to-one connections that are responsible for so many successful migrations.[15]

While there are those who want to permanently resettle, this expedition may be for those who never wanted the citizenship or asylum that another nation withholds or reluctantly bestows. Neither do they need the victimhood, racism, segregation, or bad jobs that attend migrations. They want more than the choice to change their citizenship, and they do not want to contribute to brain drain in their own country. They want another form of cosmopolitan mobility.

Temperamentally, withdrawing the request for citizenship also robs the right wing of its chief argument about nationalism and jobs. If migrating individuals do not want to stay, the right can only throw itself against an open door. Again, what seems like a submission is instead an empowering move that uses the one-to-one to move away from the one and the binary toward the many.

Need, not good-natured volunteerism, fuels the movements of an environmental exploration. There are no haves and have-nots, only needs and problems to put together in trusted relationships. There is no privileged direction of travel, since different cultural, political, and climate problems exist everywhere. And there are no solutions to migration issues, only more than 70 million responses, each corresponding to the needs of a traveling person.

Broadening what constitutes education and training, migrating individuals can form a global network for exchanging information, expertise, and physical redesign in flexible blocks of time. Global capital can migrate around the world, looking for advantageous conditions that change over time. And the wealthiest young people can go to university anywhere in the world, giving them a new fork in the road. Similarly migrating individuals might orchestrate seasonal journeys to enrich their

lives and confront the very factors that are causing migrations or mobility restrictions.

The legal apparatus that works so hard to expel people might focus instead on recognizing strings of timed journeys to acquire experience before returning home, or more robust procedures for granting international credentials in exchange for this work. While, for some, a fixed destination is appropriate, for others, there is only certainty about the next ten years of their child's education, or the next four years of college, or a need for professional reaccreditation. For still others, there might be a chance to design a global life for fifteen years of changing locations and educational opportunities.

Many problems are ripe for this matchmaking of needs. Given the graying of the world's fishing fleets, agricultural industries, and construction trades, there are opportunities for matching younger and older people, or able-bodied and disabled, in exchange for expertise that will otherwise be lost. Global networks of farmers already exchange experience about planting everything from sweet potatoes to flowers to animal husbandry. There are shortages of medical and other professionals who can complete parts of their education, internships, or research when matched with situations of need. Countries hoping to retool their economy in order to adapt to changing conditions can also recruit outside talent.[16]

And there are a growing number of exchanges in which correspondents working on forests, wildfires, and sea-level rise share expertise about the state of the planet and its changing conditions due to global warming. They index the world in terms of temperature, crops, forest cover, and mineral deposits, among many other things. A network of locations around the world with shallow floodplains, or forests sitting over oil deposits, or susceptibility to wildfires are all inching closer to each other.

In these exchanges, cities might bargain with their under-exploited spaces of failure to attract a changing influx of

talent and resources—matching their needs with the needs of mobile people to generate mutual benefits. While many nativist political platforms argue that migrating individuals exacerbate unemployment in already depressed areas, the opposite is true. Again, it is the segregation of problems that creates attrition and depression in cities. Many shrinking cities in the United States suffer from dormancy and inactivity until they are revived by migrating individuals who creat new needs, new customers, and new enterprises that get things moving again.[17] Some cities are developing green infrastructures to address climate issues, and the expertise needed to engineer and build these responses presents yet another opportunity for training.[18]

By assessing its problems as assets, the city already makes a more information-rich urban network. Cities have temporary needs, but they also have housing stock that serves different populations at different stages of life, and territories that shrink and expand with the changing fortunes of the market. In addition to wage-earning projects, the situated values of spatial variables offer in-kind contributions so that space and time, as well as failures and opportunities for training, might mix and create temporary jobs as well as no-work, nonmarket exchanges.

Again, this will surely go wrong. All the precedents for migrations and global exchanges of this kind offer nothing but cautions about trafficking, and labor abuse among other things.[19] But since these dangers are already present in abundance, what sorts of interplay strengthen existing networks with more robust choices, corroborating interdependences or checks and balances that would increase security for all parties in the exchange? Nothing works, and there are some interplays that provide more relief than others, but few things could be worse than the detentions of the contemporary status quo.

4.

The most difficult cultural narrative for the modern mind may be one without conflict. What stories about organization outside of national sovereignty can the history books offer, except dramatic portrayals of empires and bloody caliphates that must control the universe and destroy others to exist? Peace is even seen as the necessary corollary of war within the modern nation.

And many kinds of nonmilitary work take on the labels, if not the organizational dispositions, of the military. To name just a few, consider the Civilian Conservation Corps of the New Deal, the Ghana Workers Brigade and the Peace Corps of the 1960s, or the contemporary Global Brigades. Corps, brigades, and cohorts with uniforms and pledges are all too prevalent.

Young environmental activists and their targets reflect back the customary oppositional techniques of ideological activism. An eco-terrorist group like Earth Liberation Front (ELF) has the motto "if you build it, we will burn it." Fighting fire with fire, ELF burns down McMansions and sabotages industrial sites that encroach upon sensitive landscapes.[20]

Inspired by the protests of teenager Greta Thunberg, a truly global movement like Youth4Climate is gathering adherents among children, teenagers, and adults, and along politically polarized lines.[21] Predictably reinforcing the binary, some patronizing world leaders tell the teenagers who they once might have sent to war, to stop all this nonsense and get back to their lessons.[22] Teenagers facing climate change are arguably fighting for their survival, but culture finds it impossible to give authority to anything other than the customary military or economic battlefront.

Dominant cultural narratives may be even more difficult to alter than the heavy physical material of the world. The modern mind finds it ridiculously optimistic or naive to imagine

marching away from the front or deploying the national logistical apparatus to save lives and property at risk of climate change. The modern stance, accustomed to struggling against its foe until the apocalypse, finds this path of least resistance completely preposterous.

Sometimes it is necessary to run headlong toward a concentration of power in order to collide with it and break it up. While not abandoning these binary political fronts, what are the cultural narratives that might allow you to wriggle between obstructions without triggering the violence of the loop or the binary?

Not a campaign of war, the environmental exploration described here is a boundless, high-stakes expedition into a terra incognita at the intersections of inequality, climate, and migration. Temperamentally, this expedition would require a complete rewiring of deeply ingrained human habits. In this theater of activities, sovereignty, as it has been used historically, may not even be a relevant term. Responsibility for larger territories and atmospheres that nations have spoiled or abandoned overwhelms those claims.

The alteration of gigantic landscapes of weather, natural resources, and climate calls for an adventure that might even make war seem tedious and puny by comparison. The lethality of climate risks comes with the same heightened life-and-death risks that involve physical encounters with a dramatically changing landscape. Nixon asks how culture can "turn the long emergencies of slow violence into stories dramatic enough to rouse public sentiment and warrant political intervention."[23] But this adventure also replaces the blunt, violent, and repetitive activities of the human's petty wars with a need for massive global cooperation and shared intelligence. While it is nearly impossible for culture to conceive of such a thing, what if, in addition to the necessary and righteous fight, the cultural narrative was about distracting attention away from conflict with startling physical stories of spatial practices?

If the cultural imagination can be gripped by reports of a coming storm or a spreading virus, imagine cultural stories of design that encounter the full force of the climate. For instance, in the wake of Hurricane Maria, Puerto Rico scrambled for a year to restore electricity, and the only work sanctioned by FEMA was the repair of existing infrastructure, like electrical poles, that would be in danger of falling over again even in a tropical storm. But the very windiness that sometimes threatens the island is also a source of renewable energy. A field of wind turbines designed to withstand a category two or three hurricane might provide a more reliable, even uninterrupted source of energy. But they also potentially serve as a baffle to reduce damage from hurricane winds.[24] Are there similar situations where the direst consequences of climate change might actually fuel the means to alleviate them, if matched in the right interplay?

Reverse the roles in the scene of the parent who works on spatial temperament to reduce tension between squabbling children, and make the children closer to the age of the teenagers who have appeared in these discussions. Maybe the youngest explorers "know how" to shift temperament by embarking on an adventure that satisfies teenage energies while also distracting from the pyrotechnics of war that draw the attention of adults. They can rebel by deliberately not rebelling, and by obligingly taking on the problems that their elders have left behind. They will not make fools of themselves with a storybook caliphate. And the adventurous expedition within an ecology of problems defangs any patronizing aggression. Maybe those who are engineering a passage through the world are trusted to be the new global leaders, diplomats, and strategists. Their special credentials include knowledge of multiple languages and cultures as well as techniques to ease tensions and violent dispositions.

Even easier, and therefore more implausible, is a temperamental repositioning of the military or logistical apparatus to

facilitate a flow away from conflict. The moments of unrest and warfare around the world might be tragic, but the moment when people move away from them might be moments of celebration. Not only would human resources be streaming toward the rest of the world, but the contested subject of the fight would be walking away from the fight and starving it of the attention it craves and requires in order to exist. The move to quarantine during a global pandemic rehearses this potential. If the evacuation of people and resources was as carefully engineered and thoroughly financed as the invasion of territory, warmongers could routinely find themselves in a tussle over an empty box.

Medium design serves this environmental exploration because it favors interplay that activates mobility with no sense of victory or loss. If political fights have become more deadlocked as they have become more polarized, maybe overcoming inertia is prized above all. Turning on your heel and marching away from the physical fronts of war would be impossible for humanities that are addicted to head-on confrontation. It would be too easy. But in medium design, marching away from the fight and toward a massive, abundant field of environmental failure is strangely reliable and enriching.

If history is usually enthralled with binary fights, this history would focus on those organizational shifts that ease tension. Replacing the national anthems might be songs about arrival and the diffusion of fear. This is the history of things that don't happen and should not always work.

Afterword

You Know How to Be Unreasonable

Medium design is another way to work on the world. It finds special resources for that work on the flip side of some obdurate illusions of the modern mind that stifle change. Over and over in the discussion, this perspective upends cultural defaults, suggests counterintuitive approaches, and presents surprising outcomes.

Everyone is a designer, but the most practical things you know —even most of what you know—about how to design is not usually treated as authoritative knowledge. Medium design relies on common sense or cultural muscle memory—the everyday practicalities of managing your environment with know-how. But the smart modern mind that needs to be right is often dumb to this knowledge. Strangely, what pool players, cyclists, clowns, dogs, chemists, cooks, and parents know does not scale up to influence approaches to the world's most difficult dilemmas.

Medium design works on the assumption that there is no all-encompassing ideological system from which all power and violence originates. Superbugs are, among other things, evidence of other irrational desires, strange loyalties, and scrambled ideologies that are sources of violence and pathogens of authoritarianism.

While culture is often paralyzed by the most immaterial habits of mind—like its ideological loops and binaries—medium design finds alternative variables and values with which to parse the world. And these other markets and terms of exchange— present in the heaviest, physical materials, atmospheres, and

spatial relationships—are only more heightened and available in a world facing extremes of inequality and climate change.

While the design profession is usually regarded to be a hand-maiden to the market, medium design does not always have to wait on a client with a sufficient accumulation of capital. Capital is not the only force with a license to index the world. Design can begin now, with multiple varied experiments to trade these heavy values and temperaments—proximities, relationships, properties, potentials, and risks in relation to urban neighborhoods, flood zones, transportation networks, regional territories, and patterns of migration.

While medium design works with shapes and solids in space, the real object of the design is interplay—a protocol for activity between these solids and potentials. Rather than only registering information in lexical, geometric, or quantitative expressions that present a stable and reliable solution, medium design uses forms of interplay to generate a combinate chemistry of spatial elements. Interplay is an expression of interactivity within an ecology over time.

Culture often gives authority to solutions or right answers, but these are not precise enough or sturdy enough, because they lack the very things that the modern mind hopes to avoid—indeterminacy, latency, entanglement, and failure.

Solutions do not have a long enough temporal dimension to respond to changing conditions and new failures. Interplay is designed to remain in place to accommodate change and counter abuses. When things go wrong, as they inevitably will, a cooperative neighborhood arrangement, a switching protocol between transportation modalities, or a global network exchanging intelligence and training have a better chance of reacting to adjust a relationship. Designing interplays between these components works on the faders and toggles of organization mentioned in the introduction.

Because interplay sometimes works with latent potentials that may never be expressed as an event, or because it plays

out as a gradient unfolding over time, it may not garner the confidence and currency reserved for finding the right answer. But for precisely those reasons, it may be, paradoxically, more stealthy and expedient. Power often decouples its message from its real activities. Oil companies advertise with green sentiments. Populist leaders concentrate power. But, similarly, a switching protocol can entice capital and divert revenues to public transportation without announcement. Any design that works with latent potentials need not always declare its political leanings if they might draw fire or create obstacles in a politically polarized climate.

Rather than autonomy and freedom, medium design looks for anonymity and entanglement. Entanglement reinforces check and balances, and it also allows change to travel, multiply, and gain scale. These forms of interplay may be as fast as the runaway development they work to reverse engineer.

Materials for work in this medium are perhaps more accessible in direct relation to how problematic they are or to what degree they fail. Problems, ordinarily considered to be deficits, advance forward as assets on an alternative spatial ledger in which both positive and negative attributes are valuable. These are the unlikely terms of medium design exchanges—risks of flood and wildfire, problems of recial injustice and inequality, or obstacles to mobility that have the potential to initiate change.

Interplay as a form for orchestrating activity is confusing for the modern mind, that prefers objects with names. There is nothing to see. There is no new technology or gadget to display, which is the usual signal of innovation, and no modern swagger about the superiority of technology. Because the most sophisticated technologies, like contemporary digital technologies, have been shown to deliver crude dispositions, medium design looks for sophistication in the protocols that organize interplay between emergent and incumbent technologies. As the site of these mixtures, space is itself a medium of innovation.

Since nothing works in medium design, the work is never

done. There is no homeostasis, only more ways to keep things moving. Space is something that is piloted, cajoled, tended, or activated to form more interdependent relationships, and the designer is flying a plane that never lands.

If the smart modern mind is often dumb to some practical forms of knowledge, the common superbug is helpful in demonstrating just how dumb. Superbugs seem to instinctually know how to trick the modern mind and its tendency to spin around loops and binaries—the need to be right and square off against an enemy. They obligingly provide some suggestive symptoms. Medium design can work not only on the dominant cultural logics but also on the superbugs that manipulate those logics to their own ends.

Against expectation, design might be unreasonable, scrappy, and inconsistent. Superbugs lie, mirror accusations, and confuse ideological creeds. Climate change is a hoax, or democratic support of public transit is a "diamond-encrusted" form of self-enrichment for political elites. And there are countless other similar rhetorical inversions or traps. It is not the content of a lie that matters, but rather how the lie lands and bounces. Confidence games activate culture in ways that may run counter to the message expressed; beyond content, stories have disposition.

Similarly, the most successful and relentless activism is both ideological and dispositional, mixing declaration with action that is less predictable, traceable, or stable. As a final activist episode, consider recent pro-democracy demonstrations in Hong Kong that use both digital signals and physical presence to orchestrate a special resilience and stealth. Protesters send one-to-one Bluetooth signals to those within about 100 meters (330 feet), or broadcast a message to all users in the vicinity. They adopt the disposition of water in all its phases saying, "You can't shoot water," "harden like ice," "gather like dew," or "scatter like mist."[1] And the water can also boil to riot for social justice.

But the activism that is purely ideological and declarative, or only prelude to a political ultimate, often assumes a predictable binary disposition. The water cannot be mist or gas or cascade; it can only boil. And while hoping to intensify pressure on power, it may be releasing that pressure—like the addict who succumbs to a competition with drugs. Reified as event and mirroring the temperament of power, this form of protest is consequently the most easily mimicked and hijacked to serve the very power it opposes. White suburban boys playing soldier can endanger the careful plans of the Black Lives Matter movement. Trump can send in the national guard or a MAGA militia to incite the violence he needs for his own messaging. Bussing in imposters, a dictator can stage a riot useful for propaganda.

The biggest mystery of all is that the brutality of loops and binaries—however tedious, flat, and worn—can continue to attract attention for the political superbug. What does it take to drain away this sustaining lifeblood in a way that withers rather than nourishes? How tired do the scripts of human babyhood have to be? Or, from fossil fuels and political strongmen to free zones and detention camps, how boring does violence have to be?

This medium design that is never finished and offers no single object to look at can nevertheless tell more compelling and contagious stories and pull off more impossible tricks. First, design—now closer to its other associations with craftiness and calculation—is no longer merely a subject of policy and planning bureaucracy. Rather it is a subject for popular-culture stories, with a chance of drawing attention away from the narratives to which culture is addicted.

And design has as one of its resources a surprising and impossible narrative form: a story without conflict. Culture seems not to be able to conceive of either ideation or narrative without conflict. For the modern who must struggle against its foe toward the apocalypse, the history of violence that does not happen is almost unthinkable, and to some, it might even seem

like a betrayal of principles. But more important than purity and consolidated beliefs may be overcoming binary divides to address the larger goal of reducing violence and increasing justice.

The interludes in this book rehearse working in this world turned upside down, where narratives may run counter to expectations to foster dissensus and break up stubborn habits. Failure can signal winning. "No" can express positive energy. Radical purity can be temperamentally conservative. Defensive postures increase risk. Fighting is a marker of capitulation. Submission gets the upper hand. Exposure creates camouflage.

And, at the end of this book, these episodes no longer seem like only anecdotal or fleeting political successes. They are embedded in ordinary surrounding spaces that you know how to design no matter what your training. The existential risks of inequality and climate change, together with all of their precipitates in migration, structural racism, pandemic, sea-level rise, wildfires, and the destruction of sensitive landscapes is a story of titanic forces. It is a vast wilderness of failure for exploration, sustained physical exertion, streaming global manpower, and curiosity about endless experiments that can multiply without a universal denominator.

While the most well-rehearsed ideological approaches to activism must often lead, they can work hand in hand with an activism of disposition that designs relationships between the heavy physical components of space. While the conventional design apparatus may also remain in play, there are so many more aesthetic pleasures and challenges in a spatial medium. And these spatial models can offer to a broad audience techniques for modulating power in organizations of all kinds—adjusting potentials and temperaments, reducing immanent violence, checking concentrations of authority, and making the urban matrix more information-rich. The work does not need a name, and you already know how to do it. But it would be something like medium design.

Acknowledgements

This book is indebted to many. Thanks to Leo Hollis, the team at Verso, and cover designer Ayham Ghraowi.

Thanks also to those who were kind enough to read the manuscript or write on its behalf: Arjun Appadurai, Wendy Chun, Jean-Louis Cohen, Ed Dimendberg, Eik Hermann, John Durham Peters, Vyjayanthi Rao, Dubravka Sekulić, Hito Steyerl, and Ton Vidler.

Seminars and lecture courses at Yale University, The European Graduate School, and Strelka have provided an opportunity to rehearse the material in this book. Dean Deborah Berke at Yale University's School of Architecture provided support for projects related to the research included here. Thank you to Benjamin Bratton and Strelka Press for publishing a 2018 e-book essay entitled *Medium Design*. Thanks also to the institutions that sponsored related lectures or exhibitions.

Funding and recognition from the Schelling Architecture Foundation and United States Artists continues to support ongoing research.

Students and former students have assisted with research or contributed to related projects and classes. Among these are: Caroline Acheatel, Nilas Andersen, Brian Cash, Miquel Sanchez-Enkerlin, Adam Feldman, Swarnabh Ghosh, Claire Gorman, Carina Gormley, Theodossios Issaias, Samantha Jaff, Alexander Kim, Jeffrey Liu, Paul Lorenz, Laura Pappalardo, Maggie Tsang, and Matthew Wagstaff.

Finally, many thanks to colleagues and friends for their support or their invitations to contribute to lectures and

dialogues: Julieta Aranda, A. J. Artemel, Nick Axel, Anadana Beros, Martin Beck, Nicolay Boyadjiev, Craig Buckley, Claudio Bueno, Francesco Casetti, Beatriz Colomina, Santiago del Hierro, Nicholas de Monchaux, Francisco Díaz, Christopher Fynsk, David Garcia, James Graham, Stephen Graham, Nikolaus Hirsch, Beth Hughes, Amal Issa, Andrés Jaque, Bernd Kasparek, Irena Lehkozivova, Laura Kurgan, Lara Khaldi, Ann L. Lui, Ligia Nobre, Trevor Paglen, Sibylle Peters, Lorenzo Pezzani, Peg Rawes, Kim Rygiel, Mahdi Sabbagh, Yara Saqfalhait, Susan Schuppli, Felicity Scott, Mimi Sheller, Deane Simpson, Imre Szeman, Pelin Tan, Ioanna Theocharopoulou, Ben Vickers, Anton Vidokle, Mark Wasiuta, Mark Wigley, Mabel Wilson, Brian Kuan Wood, and Mimi Zeiger.

This book is dedicated to Patricia McNamara (Aunt Pat).

Notes

Preface

1 François Jullien, *The Propensity of Things: Toward a History of Efficacy in China* (New York: Zone Books, 1995), 29.
2 Karen Barad, *Meeting the Universe Halfway: Quantum Physics and the Entanglement of Matter and Meaning* (Durham and London: Duke University Press, 2007).

Introduction

1 See climate.nasa.gov; noaa.gov/news-features; climatecentral.org/news/new-analysis-global-exposure-to-sea-level-rise-flooding-18066; climatecrocks.com.
2 Kendra Pierre-Louis, "Greenhouse Gas Emissions Accelerate like a 'Speeding Freight Train'," *New York Times,* December 5, 2018.
3 Keller Easterling, *Extrastatecraft: The Power of Infrastructure Space* (London: Verso, 2014).
4 See unhcr.org/en-us/figures-at-a-glance.html.
5 UN-Habitat, "Streets as Public Spaces and Drivers of Urban Prosperity" (Nairobi, United Nations Human Settlement Program, 2013), 22; Atlas of Urban Expansion (Cambridge, MA: Lincoln Institute of Land Policy, 2012), atlasofurbanexpansion.org.
6 See webtv.un.org/%C2%BB/watch/joan-clos-un-habitat-on-land-use-and-urban-expansion-press-conference/5013631178001.
7 Vilém Flusser, *Towards a Philosophy of Photography*, trans. Anthony Mathews (London: Reaktion Books, 2000), 3–4.
8 Francis Fukuyama, "The End of History?" *The National Interest* 16 (Summer 1989), 3–18.
9 Stanley Fish, *Winning Arguments: What Works and Doesn't Work in Politics, the Bedroom, the Courtroom, and the Classroom* (New York: Harper Collins, 2016).
10 For another discussion of the concept of active form, see: Keller Easterling, *Extrastatecraft: The Power of Infrastructure Space* (New York: Verso, 2014).
11 Johan Galtung, "Violence, Peace, and Peace Research," *Journal of Peace Research* 6, no. 2, 1969; Rob Nixon, *Slow Violence and the Environmentalism of the Poor* (Cambridge, MA: Harvard University Press, 2011).
12 Jacques Rancière, *The Politics of Aesthetics* (London: Continuum, 2004), 85.

Interlude One

1 "#KAEC - King Abdullah Economic City 2015," YouTube (January 19, 2015), youtube.com/watch?v=cjyn5BP38_4; "New City Lazika," YouTube (January 16, 2013), youtube.com/watch?v=fKa3qgnZLpw; "Aras Free Zone," YouTube (July 27, 2009), youtube.com/watch?v=P199kZcBAqo.

2 A video of North Korea on its special economic zones was uploaded to YouTube on May 30, 2015. The channel was later deleted as described in Solon, Olivia, "YouTube Shuts Down North Korean Propaganda Channels," *Guardian*, September 9, 2017.

3 Coronavirus Task Force, Press Briefing Transcript, March 21, 2020, 50:41, rev.com/transcripteditor/shared/o4S5_D2oKKAy1hJuf1d8E3 SugmZlTg_SeoYIsVJ4YOd9FoZtJqfWys1RNPrHuKEc78JfjwtJ9xYeG su3QSVck6iSsM?loadFrom=PastedDeeplink&ts=3041.81

Chapter One

1 Gilbert Ryle, *The Concept of Mind* (Chicago: University of Chicago Press, 1949), 27–32.

2 Ryle, *Concept of Mind*, 25–61, 43; and Keller Easterling, *Extrastatecraft: The Power of Infrastructure Space* (New York: Verso, 2014).

3 Ryle, *Concept of Mind*, 33.

4 Michael Polanyi, *The Tacit Dimension* (Chicago: University of Chicago Press, 1966, 2009), 7, 4, 20, 78.

5 Polanyi, *Tacit Dimension*, 7, 4, 20, 78.

6 Referencing Michael Polanyi, Donald Schön, a philosopher and professor of urban planning at MIT, was a proponent of "tacit knowing" in design practices. Donald Schön, *The Reflective Practitioner: How Professionals Think in Action* (New York: Basic Books, 1983), 52; youtube.com/watch?v=Ld9QJcMiNMo.

7 Karl Polanyi, *The Great Transformation: The Political and Economic Origins of Our Time* (Boston: Beacon Press, 1944, 1957, 2001); Philip Mirowski and Dieter Plehwe, eds., *The Road from Mont Pèlerin* (Cambridge, MA: Harvard University Press), 21.

8 Michel Foucault, "The Confession of the Flesh," a roundtable interview from 1977, in *Power/Knowledge: Selected Interviews and Other Writings, 1972–1977*, ed. Colin Gordon (New York: Vintage Books, 1980), 194, 197.

9 Foucault, "The Confession of the Flesh," 194, 197.

10 Ibid.

11 Gilles Deleuze, "What Is Dispositif?" in Timothy Armstrong, trans., ed., *Michel Foucault Philosopher* (New York: Routledge, 1991), 162.

12 Giorgio Agamben, "What Is an Apparatus?" in *"What is an Apparatus?" and Other Essays*, (Redwood City, CA: Stanford University Press, 2009), 2–3, 7, 10, 14. Agamben uses the phrase "family of terms" in a related text: Giorgio Agamben, "What Is a Dispositor?" 2005, online lecture transcript by Jason Michael Adams, eclass.upatras.gr/modules/document/file.php/ARCH213/Agamben%20Dispositor.pdf, accessed December 18, 2019, unpaginated.

13 Michel Foucault, "Governmentality," in *The Foucault Effect: Studies in Governmentality*, edited by Graham Burchell, Colin Gordon, and Peter Miller (Chicago: University of Chicago Press, 1991), 92, 93. Foucault writes that governance is "essentially concerned with answering the question of how to introduce economy—that is to say, the correct manner of managing individuals, goods and wealth within the family (which a good father is expected to do in relation to his wife, children and servants) and of making the family fortunes prosper—how to introduce this meticulous attention of the father towards his family into the management of the state."

14 Giorgio Agamben, "What Is an Apparatus?," 14. Agamben translates as "network" [*le réseau*] the phrase "system of relations" that appears in the *Power/Knowledge* translation of "The Confession of the Flesh."

15 J. J. Gibson, "The Theory of Affordances," in *The Ecological Approach to Visual Perception* (London: L. Erlbaum, 1979), 127–41. The first book in which Gibson mentions the idea of affordance is J. J. Gibson, *The Senses Considered as Perceptual Systems* (London: Allen and Unwin, 1966).

16 Gibson, "The Theory of Affordances," 134, 127, 128, 129.

17 One of the first uses of the word in relation to design appeared in Don Norman, *The Design of Everyday Things* (New York: Basic Books, 2013, revised and expanded edition). The book was first published in 1988 with the title *The Psychology of Everyday Things*.

18 Bruno Latour, "How Better to Register the Agency of Things," Tanner Lectures, Yale University, March 26–27, 2014.

19 Latour, "How Better to Register the Agency of Things."

20 Pierre Bourdieu, *Outline of a Theory of Practice* (Cambridge: Cambridge University Press, 1977) and *The Logic of Practice* (Stanford, CA: Stanford University Press, 1990) stand near the beginning of a long bibliography that explores Bourdieu's use of "disposition."

21 Bruno Latour, *We Have Never Been Modern* (Cambridge, MA: Harvard University Press,1991), 48.

22 Jane Bennett, *Vibrant Matter: A Political Ecology of Things* (Durham, NC: Duke University Press, 2010), xvii, 34.

23 Bennett, *Vibrant Matter*, 108, 25.

24 Rosalind Williams, "Cultural Origins and Environmental Implications of Large Technological Systems," *Science in Context* 6, no. 2: 1993, 395.

25 Bennett, *Vibrant Matter*, 28, 33, 38.

26 Bennett, *Vibrant Matter*, xix, 106–7.

27 Bennett, *Vibrant Matter*, 36, 38.

28 John Durham Peters, *The Marvelous Clouds: Toward a Philosophy of Elemental Media* (Chicago: University of Chicago Press, 2015), 46, 2; see also Antonio Somaini, "Walter Benjamin's Media Theory: The Medium and the Apparat," *Grey Room* 62 (Winter 2016), 6–41; and Craig Buckley, Rüdiger Campe, and Francesco Casetti, eds. *Screen Genealogies: From Optical Device to Environmental Medium* (Amsterdam: Amsterdam University Press, 2019).

29 John Durham Peters, *The Marvelous Clouds*, 2.

30 Joseph Vogl, "Becoming-media: Galileo's Telescope," in *Grey Room*

29 (Winter 2008), 14–16; see also Eva Horn, "Air as Medium," *Grey Room* 73 (Fall 2008), 6–25.

31 Durham Peters, *The Marvelous Clouds*, 9, 38.

32 Durham Peters, *The Marvelous Clouds*, 10, 8

33 Karen Barad, *Meeting the Universe Halfway: Quantum Physics and the Entanglement of Matter and Meaning* (Durham and London: Duke University Press, 2007), 392, 394, 396.

Interlude Two

1 Richard Gid Powers, *Not Without Honor: The History of American Anticommunism* (New Haven: Yale University Press, 1998), 270–71.

Chapter Two

1 Atlas of Urban Expansion (Cambridge, MA: Lincoln Institute of Land Policy, 2012), atlasofurbanexpansion.org; webtv.un.org/%C2%BB/watch/joan-clos-un-habitat-on-land-use-and-urban-expansion-press-conference/5013631178001.

2 Atlas of Urban Expansion; webtv.un.org/%C2%BB/watch/joan-clos-un-habitat-on-land-use-and-urban-expansion-press-conference/5013631178001.

3 Thomas Piketty, *Capital in the Twenty-First Century* (Cambridge, MA: Harvard University Press, 2013).

4 James Holston, "Autoconstruction in Working-Class Brazil," *Cultural Anthropology* 6, no. 4, November 1991: 447–65.

5 Hernando de Soto, "Les Pauvres Contre Piketty," *Le Point,* April 14, 2015.

6 Hernando de Soto, *The Mystery of Capital: Why Capitalism Triumphs in the West and Fails Everywhere Else* (New York: Basic Books, 2000).

7 Michael Casey and Paul Vigna, *The Truth Machine: The Blockchain and the Future of Everything* (New York: St. Martin's Press, 2018), 175–88; chromaway.com; landing.bitland.world; ubitquity.io.

8 "Vitalik Buterin explains Ethereum" (July 29, 2014), youtube.com/watch?v=TDGq4aeevgY.

9 Eric A. Posner and E. Glen Weyl, *Radical Markets: Uprooting Capitalism and Democracy for a Just Society* (Princeton: Princeton University Press, 2018), xxi.

10 Posner and Weyl, *Radical Markets*, xviv, xvii–xviii.

11 Posner and Weyl, *Radical Markets*, xviv, xvii–xviii, xv, 250, 293.

12 David Harvey, *Rebel Cities: From the Right to the City to the Urban Revolution* (London: Verso, 2012).

13 S. Matthew English, "Blockchain Land Registry May Lead to New Global Financial Crisis," Cointelegraph, September 4, 2016, https://cointelegraph.com/news/blockchain-land-registry-may-lead-to-new-global-financial-crisis.

14 Easterling, *Extrastatecraft*, 137–49.

15 James C. Scott, *Seeing Like a State: How Certain Schemes to Improve*

the Human Condition Have Failed (New Haven: Yale University Press, 1998), 6, 311, 313, 315, 7.

16 Ebenezer Howard, *To-Morrow: A Peaceful Path to Real Reform* (London: Swan Sonnenschein & Co., 1898); Robert Fishman, *Urban Utopias in the Twentieth Century: Ebenezer Howard, Frank Lloyd Wright, Le Corbusier* (Cambridge, MA: MIT Press, 1982), 23–87.

17 Ioanna Theocharopoulou, *Builders, Housewives and the Construction of Modern Athens* (New York: Black Dog Publishing, 2017), 181–82; Platon Issaias, "The Absence of Plan as a Project: On the Planning Development of Modern Athens 1830–2010" in *The City as a Project*, ed. Pier Vittorio Aureli (Berlin: Ruby Press, 2013); Konstantina Kalfa, "Antiparochì and (its) Architects: Greek Architectures in Failure" in Arindam Dutta et al., eds., *Systems and the South: Architecture in Development* (Cambridge, MA: MIT Press, 2020).

18 Theocharopoulou, *Builders, Housewives and the Construction of Modern Athens*, 181–82.

19 UN-Habitat, "Streets as Public Spaces and Drivers of Urban Prosperity," Nairobi, United Nations Human Settlement Program, 2013, 55; Atlas of Urban Expansion (Cambridge, MA: Lincoln Institute of Land Policy, 2012), atlasofurbanexpansion.org; Patrick Lamson-Hall, Shlomo Angel, and Yang Liu, "The State of the Streets: New Findings from the *Atlas of Urban Expansion*—2016," Working Paper WP18PL1, Lincoln Institute of Land Policy, 2018.

20 UN-Habitat, "Streets as Public Spaces"; *New Urban Agenda*, United Nations, 2017.

21 UN-Habitat, "Streets as Public Spaces," vi.

22 "Remaking the Urban Mosaic: Participatory and Inclusive Land Readjustment," UN-Habitat, 2016, 5, 17, 8; "Global Experiences in Land Readjustment" (UN-Habitat, 2018).

23 "Remaking the Urban Mosaic," 5, 17, 8.

24 "Remaking the Urban Mosaic"; "Urban Regeneration: Ahmedabad," The World Bank, urban-regeneration.worldbank.org/Ahmedabad, accessed December 23, 2018.

25 AbdouMaliq Simone and Edgar Pieterse, *New Urban Worlds: Inhabiting Dissonant Times* (New York: Wiley, 2017).

26 "Remaking the Urban Mosaic," UN-Habitat, 2016, 82.

27 See changingground.org, accessed December 23, 2018; youtube.com/watch?v=cwCbpV3crYQ&feature=youtu.be, accessed December 24, 2018.

28 See changingground.org, accessed December 23, 2018; youtube.com/watch?v=cwCbpV3crYQ&feature=youtu.be, accessed December 24, 2018.

29 Franco Moretti and Dominique Pestre, "Bankspeak: The Language of World Bank Reports, 1946–2012," *New Left Review* 92, March–April 2015, 77, 79, 80–83, 96-99.

30 Robert J. Sampson, *Great American City: Chicago and the Enduring Neighborhood Effect* (Chicago: University of Chicago Press, 2012); Douglas S. Massey, *Categorically Unequal: The American Stratification System* (New York: Russell Sage Foundation, 2007); Raj Chetty et al.,

"Where is the Land of Opportunity? The Geography of Intergenerational Mobility in the United States," National Bureau of Economic Research, June 2014, equality-of-opportunity.org/assets/documents/mobility_geo.pdf; "In Climbing Income Ladder, Location Matters," *New York Times*, July 22, 2013.

31 Abhijit V. Banerjee, *Making Aid Work* (Cambridge, MA: MIT Press, 2007); Abhijit V. Banerjee and Esther Duflo, *Poor Economics: A Radical Rethinking of the Way to Fight Global Poverty* (New York: Public Affairs, 2011).

32 Banerjee, *Making Aid Work*; Banerjee and Duflo, *Poor Economics*, 61–62.

Interlude Three

1 Caroline Levine, *Forms: Whole, Rhythm, Hierarchy, Network* (Princeton: Princeton University Press, 2016), 2, 3.

2 Levine, *Forms*, 1, 3, 6, 16.

3 Levine, *Forms*, 148, viii, 113, 3. Levine does not reference Jane Bennett when using the term "political ecology."

4 Jacques Rancière, *Hatred of Democracy* (London: Verso, 2014), 61–62.

5 Rancière, *Hatred of Democracy*, 61–62.

Chapter Three

1 The Earth Institute, Columbia University, "Transforming Personal Mobility," August 10, 2012. wordpress.ei.columbia.edu/mobility/files/2012/12/Transforming-Personal-Mobility-Aug-10-2012.pdf. See footnote 1: "The term 'Mobility Internet' was first coined in William J. Mitchell, Christopher Borroni-Bird, and Lawrence D. Burns, *Reinventing the Automobile: Personal Urban Mobility for the 21st Century*. The MIT Press, 2010."

2 Matthew Claudel and Carlo Ratti, "Full speed ahead: How the driverless car could transform cities," McKinsey & Company, August 2015, mckinsey.com/business-functions/sustainability/our-insights/full-speed-ahead-how-the-driverless-car-could-transform-cities.

3 The Earth Institute, "Transforming Personal Mobility."

4 James M. Anderson et al., "Autonomous Vehicle Technology: A Guide for Policymakers," RAND, 2016, rand.org/pubs/research_reports/RR443-2.html.

5 Bruno Latour, *Aramis, or the Love of Technology* (Cambridge, MA: Harvard University Press,1999).

6 Urban Network Analysis Toolbox for ArcGIS, MIT City Form Lab, cityform.mit.edu/projects/urban-network-analysis.html.

7 Nicholas de Monchaux, *Local Code: 3,659 Proposals About Data, Design, and the Nature of Cities* (Princeton: Princeton Architectural Press, 2016).

8 Jane Jacobs, *The Death and Life of Great American Cities* (New York: Random House, 1961), 430–31, 438, 443.

9 Jacobs, *Great American Cities*, 432–33.

10 "The Charter of the New Urbanism," Congress for the New Urbanism, cnu.org/who-we-are/charter-new-urbanism.

11 Christopher Alexander, "The City Is Not a Tree," *Architectural Forum* 122:1 (April 1965), 58–62.

12 Alexander's text directed the designer to set up systems that assigned number values to components and relationships of urbanism. He wrote, "The task of design is not to create form which meets certain conditions, but to create such an order in the ensemble that all the variables take the value o. The form is simply that part of the ensemble over which we have control." *Notes on the Synthesis of Form* (Cambridge, MA: Harvard University Press, 1964), 27.

13 Gregory Bateson, *Steps to an Ecology of Mind* (Chicago: University of Chicago Press, 2000), 21, 272, 315, 381, 462, 472.

14 Gregory Bateson, *Mind and Nature: A Necessary Unity* (Cresskill, NJ: Hampton Press, 2002 [1979]), 101.

15 Bateson, *Steps to an Ecology of Mind*, 464, 472.

16 César Hidalgo, *Why Information Grows: The Evolution of Order, from Atoms to Economies* (New York: Basic Books, 2015).

17 Hidalgo, *Why Information Grows*, Introduction and Chapter 1, xix.

18 For a discussion of switching in the mid-twentieth-century transportation landscape, see: Keller Easterling, *Organization Space: Landscapes, Highways and Houses in America* (Cambridge, MA: MIT Press, 1999).

19 "Self Driving versus Driverless - A Mobility Update with Alain Kornhauser #CES2107," youtube.com/watch?v=_HucrtH1h4U.

20 renault.co.uk/concept-cars/symbioz.html.

21 Nathan Robinson, "Why Elon Musk's SpaceX Launch Is Utterly Depressing," *Guardian*, February 7, 2018.

22 Ibid.

23 Hiroko Tabuchi, "How the Koch Brothers Are Killing Public Transit Projects Around the Country," *New York Times*, June 19, 2018.

Chapter Four

1 "Sen. Inhofe Delivers Major Speech on the Science of Climate Change," at inhofe.senate.gov.

2 "An Eco-Modernist Manifesto," The Breakthrough Institute, ecomodernism.org, accessed November 19, 2018. See also: critiques of the Breakthrough Institute in Déborah Danowski and Eduardo Viveiros de Castro, *The Ends of the World* (Cambridge, UK: Polity Press, 2014 [English translation 2017]); and T. J. Demos, "To Save a World: Geoengineering, Conflictual Futurisms, and the Unthinkable, *e-flux* 94, October 2018, e-flux.com/journal/94/221148/to-save-a-world-geoengineering-conflictual-futurisms-and-the-unthinkable/, accessed November 19, 2018.

3 "An Eco-Modernist Manifesto," The Breakthrough Institute.

4 Bruno Latour, "Love Your Monster: Why we must care for your

technologies as we do our children," *Breakthrough Journal,* no. 2, 2011, 22, 20, 25.

5 Gregory P. Hamer and Derek Abbott, "Game Theory: Losing Strategies Can Win by Parrondo's Paradox" *Nature* 402, December 1999.

6 Gregory Bateson, *Steps to an Ecology of Mind* (Chicago: University of Chicago Press, 2000), 458.

7 Frederick Law Olmsted, "Chicago in Distress," *The Nation,* November 9, 1871.

8 Benton MacKaye, "The New Exploration: Charting the Industrial Wilderness," *Survey Graphic* 54 (1925), 179, 153, 154; Benton MacKaye, "The New Northwest Passage," *The Nation* 122 (June 2, 1926), 603; Benton MacKaye, "Industrial Exploration," serial publication in *The Nation:* "I. Charting the World's Commodity Flow," 125 (July 20, 1927), 71. MacKaye used the word *incognito* in "The New Exploration" and *terra incognita* in "The New Northwest Passage," "Charting the World's Commodity Flow."

9 Benton MacKaye, "The New Exploration: Charting the Industrial Wilderness," 179, 153, 154.

10 Keller Easterling, *Organization Space: Landscapes, Highways and Houses in America* (Cambridge, MA: MIT Press, 1999), 12–67.

11 Grassroots Economics, an NGO in Kenya, is using the Ethereum-based Bancor Protocol in Mombasa. Ben Munster, "A Mombasa Slum Looks to Digital Currency to Escape Poverty," DeCrypt Media, August 28, 2018, decryptmedia.com/2018/08/28/decentralizing-africa/; Asia Initiatives is currently operating pilot projects with Social Capital Credit in India, Ghana, Kenya, and Costa Rica, asiainitiatives.org/soccs/.

12 "Introduction to SoCCs," asiainitiatives.org/soccs/introduction-to-soccs/, accessed May 6, 2019; "SoCCs Overview" and "SoCCs Manual," courtesy of founder Geeta Mehta.

13 Elizabeth Gudrais, "A Conversation with Rahul Mehrotra," *Harvard Magazine,* April 13, 2012, harvardmagazine.com/2012/04/conversation-with-rahul-mehrotra; see also rmaarchitects.com/category/community-toilets/, accessed May 6, 2019.

14 See greenprintpartners.com, accessed October 29, 2019.

15 Mike Maciag, "Analysis: Areas of the U.S. With Most Floodplain Population Growth," Governing, August 2018, governing.com/gov-data/census/flood-plains-zone-local-population-growth-data.html; Lisa Friedman, "Trump Signs Order Rolling Back Environmental Rules on Infrastructure, *New York Times,* August 15, 2017.

16 David L. Peterson, "Climate Change Intensifying Wildfire on National Forests," US Forest Service, June 2, 2016, fs.fed.us/blogs/climate-change-intensifying-wildfire-national-forests; "Infographic: Western Wildfires and Climate Change," Union of Concerned Scientists, July 22, 2013, ucsusa.org/resources/western-wildfires-and-climate-change.

17 See nrs.fs.fed.us/data/wui/state_summary.

18 See up.com/timeline/index.cfm, accessed March 14, 2020.

19 Alvin E. Roth, *Who Gets What—And Why* (New York: Houghton Mifflin Harcourt, 2015); Nancy Shute, "How an Economist Helped

Patients Find the Right Kidney Donors," *NPR*, June 11, 2015, npr. org/sections/health-shots/2015/06/11/412224854/how-an-economist-helped-patients-find-the-right-kidney-donor, accessed December 23, 2018; Paul Solman, "The Economic Principle That Powers This Kidney Donor Market," *PBS NewsHour*, August 16, 2018, pbs.org/newshour/show/the-economic-principle-that-powers-this-kidney-donor-market, accessed December 23, 2019.

20 buyersbewhere.com; Hari Sreenivasan, "How Decades of Houston Development Add up to Rising Flood Risk," *PBS NewsHour*, February 5, 2018, pbs.org/newshour/show/how-decades-of-houston-development-add-up-to-rising-flood-risk, accessed December 24, 2019.

21 See nj.gov/dep/greenacres/blue_flood_ac.html.

22 Franklin Delano Roosevelt, Oglethorpe University address: The New Deal, May 22, 1932.

23 Benton MacKaye, *The New Exploration: A Philosophy of Regional Planning* (New York: Harcourt, 1928), 205, 212–14.

24 Bruno Latour, *Down to Earth: Politics in the New Climate Regime* (New York: Wiley, 2018), 40, 54, 55, 56.

25 Anna Lowenhaupt Tsing, *The Mushroom at the End of the World: On the Possibility of Life in Capitalist Ruins* (Princeton: Princeton University Press, 2015), 156.

Interlude Five

1 "Foreign Fighters: An Updated Assessment of the Flow of Foreign Fighters to Syria and Iraq," The Soufan Group (New York, December 2015), https://thesoufancenter.org/research/, accessed March 14, 2020; Richard Barrett, "Foreign Fighters in Syria," the Soufan Group (New York, 2014), https://thesoufancenter.org/research/page/2/, accessed March 14, 2020. In 2014, there were 12,000 foreign fighters from 81 countries, and by the end of 2015, there were 27,000 to 31,000 from 86 countries.

2 Two popular clerical authorities are Ahmad Musa Jibril and Musa Cerantonio. Joseph A. Carter, Shiraz Maher, and Peter R. Neumann, "#Greenbirds: Measuring Importance and Influence in Syrian Foreign Fighter Networks," International Centre for the Study of Radicalisation and Political Violence (London, 2014).

3 Steven Morris, "British woman who joined Isis is jailed for six years," *Guardian*, February 1, 2016; Kimiko de Freytas-Tamura, "Teenage Girl Leaves for ISIS, and Others Follow," *New York Times*, February 24, 2015.

4 Barrett, "Foreign Fighters in Syria"; Rukmini Callimachi, "ISIS and the Lonely Young American," *New York Times*, June 27, 2015.

5 De Freytas-Tamura, "Teenage Girl Leaves for ISIS, and Others Follow."

6 "A Course in the Art of Recruiting," collected and organized by Abu Amru Al Qa'idy; archive.org/stream/ACourseInTheArtOfRecruiting-RevisedJuly2010/A_Course_in_the_Art_of_Recruiting_-_Revised_July2010_djvu.txt; Callimachi, "ISIS and the Lonely Young American."

7 Rachel Briggs Obe and Tanya Silverman, "Western Foreign Fighters: Innovations in Responding to the Threat," Institute for Strategic Dialogue (London, 2014).

8 Joby Warrick, *Black Flags: The Rise of ISIS* (New York: Knopf Doubleday, 2015).

9 Shiv Malik, "The ISIS Papers: Behind 'Death Cult' Image Lies a Methodical Bureaucracy," *Guardian,* December 7, 2015; see also Barrett, "Foreign Fighters in Syria"; Carter et al., "#Greenbirds"; Briggs Obe and Silverman, "Western Foreign Fighters."

10 Gregory Bateson, *Steps to an Ecology of Mind* (Chicago: University of Chicago Press, 2000), 68.

11 See youtube.com/user/abdullahx.

Chapter Five

1 Francis Fukuyama, "The End of History?", *The National Interest,* 1989.

2 Tim McDonnell, "Climate Change Creates a New Migration Crisis for Bangladesh," *National Geographic,* January 24, 2019.

3 United Nations High Commissioner for Refugees, "Protracted refugee situations: the search for practical solutions," in *The State of the World's Refugees,* unhcr.org/4444afcb0.pdf.

4 Johan Galtung, "Violence, Peace and Peace Research," *Journal of Peace Research* 6, no. 2 (1969), 168, 181, 185–6.

5 Rob Nixon, *Slow Violence and the Environmentalism of the Poor* (Cambridge, MA: Harvard University Press, 2011), 10, 11, 12, 16.

6 Gilbert Ryle, *The Concept of Mind* (Chicago: University of Chicago Press, 1949), 33.

7 Gregory Bateson, *Mind and Nature: A Necessary Unity* (Cresskill, NJ: Hampton Press, 2002, reprint from 1979), 101.

8 That is, the intelligence agencies of Australia, Canada, New Zealand, the UK, and the United States.

9 Stuart Dredge, "What is Tor? A Beginner's Guide to the Privacy Tool," *Guardian,* November 5, 2013.

10 Eyder Peralta, "N.H. Public Library Resumes Support Of 'Tor' Internet Anonymizer," NPR, September 16, 2015.

11 See libraryfreedomproject.org.

12 "Reducing Infant Mortality Starts With Listening to Women in This City," December 27, 2018, pbs.org/newshour/show/reducing-infant-mortality-starts-with-listening-to-women-in-this-city; The Community Builders, tcbinc.org/news-ideas.html; Cradle Cincinnati, cradlecincinnati.org/; tcbinc.org/where-we-work/properties/item/5231-the-pointes-at-avondale.html.

13 "Ruth Wilson Gilmore Makes the Case for Abolition," *The Intercept,* June 10, 2020. See also: reclaimtheblock.org and whitebirdclinic.org.

14 Mimi Sheller, *Mobility Justice: The Politics of Movement in an Age of Extremes* (New York: Verso, 2018).

15 The MANY project experimented with an online platform that would

facilitate migration through an exchange of needs, kellereasterling.com/exhibitions.

16 Educational Commission for Foreign Medical Graduates, ecfmg.org/; Global Health Corps, ghcorps.org; Encore, encore.org.

17 "Bright Spots in Welcoming and Integration," White House Task Force on New Americans, June 2016, obamawhitehouse.archives.gov/sites/default/files/docs/bright_spots_report_63016.pdf; "Impact of Refugees in Central Ohio," Community Research Partners, 2015, crisohio.org/wp-content/uploads/2016/04/IMPACT-OF-REFUGEES-ON-CENTRAL-OHIO_2015-SP_I.pdf.

18 US Forest Service, fs.fed.us/; Trees for Cities, treesforcities.org; Earth Corps, earthcorps.org; Mesa, mesaprogram.org.

19 While the sorts of exchanges outlined do not involve wage labor, labor networks present troubling cautions. The Philippine Overseas Employment Agency (POEA) finds jobs (1,687,831 in 2011) for millions of its citizens all over the world, but many of these are among the hardest and poorest paid; poea.gov.ph.

20 See the documentary *If a Tree Falls: A Story of the Earth Liberation Front*, dirs. Marshall Curry and Sam Cullman, 2011.

21 See clubofrome.org/2019/03/14/the-club-of-rome-supports-global-student-climate-protests.

22 Joe Watts, "Theresa May Criticises Schoolchildren Protesting Against Looming Climate Disaster for Wasting Lesson Time," *Independent*, February 15, 2019; "Scott Morrison tells students striking over climate change to be 'less activist'," *Guardian*, November 26, 2018.

23 Rob Nixon, *Slow Violence and the Environmentalism of the Poor*, 3.

24 Bjorn Carey, "Offshore Wind Farms Could Tame Hurricanes Before They Reach Land, Stanford-Led Study Says," *Stanford Report*, February 26, 2014.

Afterword

1 Ilaria Maria Sala, "Hong Kong's 'Be Water' Protests Leave China Casting About for an Enemy," *Guardian*, August 30, 2019; Jane Wakefield, "Hong Kong Protesers Using Bluetooth Bridgefy App," *BBC News*, September 3, 2019; Jamil Anderlini, "Hong Kong's 'Water Revolution' Spins Out of Control," *Financial Times*, September 2, 2019.

Index